IMAGES
of America

CAMANO ISLAND

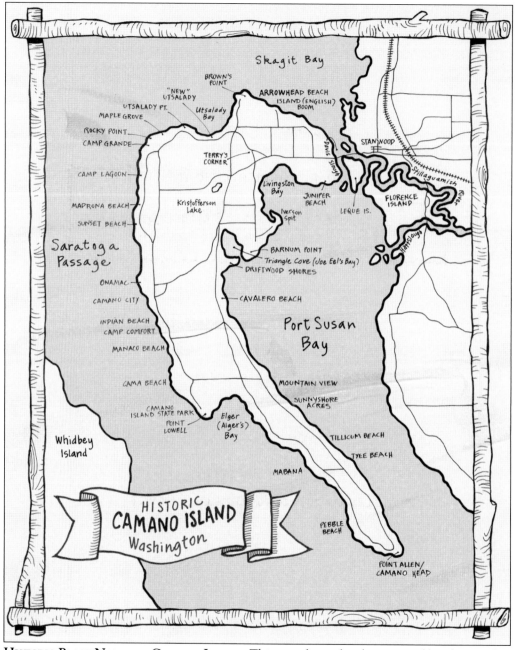

HISTORIC PLACE NAMES OF CAMANO ISLAND. This map shows the places named by white settlers when they arrived, bought, and platted the area. See the bibliography on page 127 for resources on Native American history place names. For the stories of these names, please read on.

ON THE COVER: PICNIC ON NORTHWESTERN SHORELINE OF CAMANO ISLAND. For Stanwood townsfolk, Utsalady and Rocky Point were popular destinations for excursions and picnics, especially after the Utsalady mill closed in 1891 and Stanwood became the commercial center of the area. This event is thought to be a Methodist church picnic.

IMAGES

of America

CAMANO ISLAND

Karen Prasse and the
Stanwood Area Historical Society

ARCADIA
PUBLISHING

Published by Arcadia Publishing
Charleston SC, Chicago IL, Portsmouth NH, San Francisco CA

Printed in the United States of America

Library of Congress Catalog Card Number: 2006921509

For all general information contact Arcadia Publishing at:
Telephone 843-853-2070
Fax 843-853-0044
E-mail sales@arcadiapublishing.com
For customer service and orders:
Toll-Free 1-888-313-2665

Visit us on the Internet at www.arcadiapublishing.com

CONTENTS

ACKNOWLEDGMENTS

All images are from Stanwood Area Historical Society collections unless otherwise noted. Over the years, dozens of generous people have donated or shared their family and historical photographs and information about Camano Island to help preserve and interpret area history. I sincerely thank Dave Eldridge and the board of the Stanwood Area Historical Society for use of their photographs in this book.

Images (or information) used in this book were donated by Pat Major and the South Camano Grange, Darlene Waite, Ivy Hansen, Marion Larson Turner, the Utsalady Ladies Aid, Arnold Libby, Ole Eide, Don Moa, Grace Cornwell, Mary Margaret Haugen, Gloria and C. M. Kertson, Alex Ekle, Ada Brown Hunter, Delores Jones, Cliff and Shirley Danielson, Donna Shroyer, Elaine Boren, Evelyn Moshier, Katherine Lund, Harry L. Lund, Bill Garrison, Bert Garrison, Astrid Tengelin, Elsie Tjerne, Pat Kristoferson, Janet Huntley, Amaryllis Whitmarsh, Christine Harnden, Inga Bast, Gayle Ovenell, Betty Bonjorni, Carolin Barnum DiLorenzo, Priscilla Barnum Guitteau, Jerry Nielson, Joyce Rickman, Berniece Leaf, the Hagstrom family, Karen and Asko Hamalainen, and Sandra and Gary Worthington.

Photographers include J. Boyd Ellis, who documented much of Washington State with street-view postcards; Darius Kinsey; John T. Wagness; and Robert Johnson, who documented the logging camps. Many were snapshots recording the daily activities by residents, which have become universal and unique at the same time as each era succeeds itself.

We are grateful to interviewers Ole and Evelyn Eide and Jessica Stone (Cama Beach Oral History Collection) for oral histories that add much of local interest and details of living on Camano Island in earlier eras.

Finally it is never possible to research without the use of one's public library, in this case Sno-Isle Libraries and their interlibrary loan services. Thanks also to the Puget Sound Maritime Historical Society; Pat Doran, Skagit County History Museum; Janet Enzmann, Island County Historical Society; Island County auditors and commissioners staffs; and the Washington State Library and Archives. I also thank Dennis Conroy, Joan Robinson, Renee Marquette (map), Margaret Riddle, Louise Lindgren, David Cameron, Dave Pinkham, and John Dean and the Stanwood Camano News staff. Last, but hardly least, thanks to Arcadia editor Julie Albright for giving us the opportunity to publish this book and of course my husband, Jack Archibald, for his encouragement.

INTRODUCTION

Islands are special places. Their identities are neatly defined by waterways that were once the thoroughfares of commerce and travel. Camano Island, one of the largest of dozens of islands in the Puget Sound, sits in the northwestern corner of the contiguous United States. It is separated from the Snohomish County mainland by two narrow waterways—Davis Slough (named for an early settler) and the south and west passes of the old channel of the Stillaguamish River, which forms an island in between called Leque Island.

Camano Island is between 39 and 45 square miles with about 52 miles of shoreline. It is about 18 miles from the southern headland, or cape, called Camano Head to Utsalady Bay at the north end. From Sunset Drive above Saratoga Passage east to Davis Slough, it is just under seven miles wide.

Geologically, Camano Island and the surrounding Puget Trough were once under a glacier almost a mile thick; it receded 10,000–12,000 years ago. Early accounts by discoverers describe its heavy timber, soon to become its first economic resource. Generations of this timber had been growing since this ice age, and remnant stumps from the old growth remain in undisturbed corners of Camano.

Current archaeological evidence shows humans began living here about 6,000 years ago. The general name of the cultural group of Native Americans in this part of Puget Sound is called the Coast Salish. The local tribes living around Skagit and Utsalady Bays were the Kik-ial-lus, who were closely associated with people of the Upper Skagit River. The Snohomish people had villages along the Snohomish River and on the southern part of Whidbey Island, as well as summer villages on southern Camano. It seems logical that the Stillaguamish people also camped on Camano at different times, especially near Juniper Beach. The winter and summer villages of the native people were observed first by Captain Vancouver and Lieutenant Whidbey as they explored the Puget Sound in 1892. The Snohomish people told stories of a great landslide at Camano Head and flooding of Hat Island in the 1830s that killed many people camped there.

On June 1, 1792, Vancouver's expedition anchored between Camano Head and Hat Island. From there, both the HMS *Discovery* and its tender, the *Chatham*, proceeded about six miles up what Vancouver named Port Susan Bay. The *Chatham* grounded for a few hours and they were not able to find another route north. Unable to see the tidal channels of the sloughs and the mouth of the Stillaguamish River, they turned south again, never recognizing Camano as an island.

It was not until the U.S. Exploring Expedition of 1838–1842 that Camano was identified and listed as McDonough's Island. The passage Vancouver referred to as Port Gardner was changed to Saratoga Passage. Port Gardner, now the body of water near Everett, was named for Sir Alan Gardner, Vancouver's old navy commander for which Point Allen (also known as Camano Head) was also named. A 1790 Spanish map identified a body of land east of Admiralty Inlet as Boca de Caamano. But the British renamed Camano in 1847 for Don Jacinto Caamano, who explored Nootka Sound about the same time as Vancouver. Caamano never saw his namesake; he explored the waters around Vancouver Island.

When the first settlers came to the Puget Sound, they were busy establishing "ownership" of the lands through treaties with the Native People. There were 80 native signers of the 1855 Treaty of Point Elliot at Mukilteo. They were promised many services they did not receive or only partially received, such as fishing rights, schooling and skills education, medical care, and vaccinations. Their lives were changed forever.

Camano Island is one of five islands in Island County—Whidbey, Camano, Smith's, Deception, and Ben Ure's. Two islands not originally included in the boundaries of any county located near Deception Pass are Strawberry Island and Baby Island. They soon may be added to Island County and the county will then have seven islands. Island County formed in 1853, the same year Washington Territory was formed out of the Oregon Territory. For one year, it included Whatcom, Skagit, the San Juan Islands, and Snohomish Counties. In 1854, Whatcom separated. In 1861, Snohomish County was formed, leaving Camano politically and historically tied to Island County but separated by Saratoga Passage. At first that was not a problem. Activities in Utsalady Bay were then connected to Penn Cove on Whidbey Island. But when railroads and automobiles became the main form of transportation, this left Camano isolated from its governmental center, becoming more and more commercially tied to Stanwood across the short, easily bridged stretches of the Davis Slough and Stillaguamish River. Much of Camano Island's history is influenced by this geographical anachronism, contributing to both its isolation and its independent character.

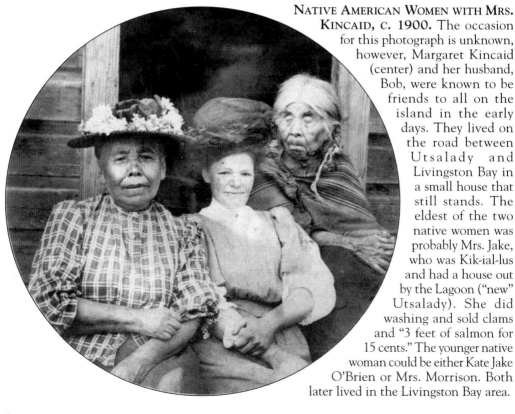

NATIVE AMERICAN WOMEN WITH MRS. KINCAID, C. 1900. The occasion for this photograph is unknown, however, Margaret Kincaid (center) and her husband, Bob, were known to be friends to all on the island in the early days. They lived on the road between Utsalady and Livingston Bay in a small house that still stands. The eldest of the two native women was probably Mrs. Jake, who was Kik-ial-lus and had a house out by the Lagoon ("new" Utsalady). She did washing and sold clams and "3 feet of salmon for 15 cents." The younger native woman could be either Kate Jake O'Brien or Mrs. Morrison. Both later lived in the Livingston Bay area.

One

THE BIG MILL
AT UTSALADY

In the years leading up to the Civil War, a few entrepreneurial and adventurous men left their homes to seek their fortunes and found their way to the Washington Territory. Some of these were East Coast lumbermen who noticed that the tall Douglas fir trees were a potential cash crop. Loggers at Penn Cove on Whidbey Island recognized the value of the timber on Camano Island, especially at a place called Acala'di, or what became known as Utsalady, commonly thought to mean "place of berries." There was a village of people there, the Kik-ial-lus, related to the Skagit Indians, one the many groups of Coast Salish people in Puget Sound and British Columbia.

When logging began there, the trees were first cut to be used as spars or pilings. The captains loaded these spars and logs for pilings in their tall ships to carry them to San Francisco or foreign ports. Utsalady has a steep, rocky beach that teams with smelt in the late summer. Its deep bay is sheltered from the southerly prevailing winds, thus making it an excellent harbor. It faces north toward Whidbey with Skagit Bay and Mount Baker to the northeast. Utsalady Bay opens into Skagit Bay, fed by the Skagit River and the west pass of the Stillaguamish River, both of which would bring millions of logs to be sawn at the mill in the next 25 years.

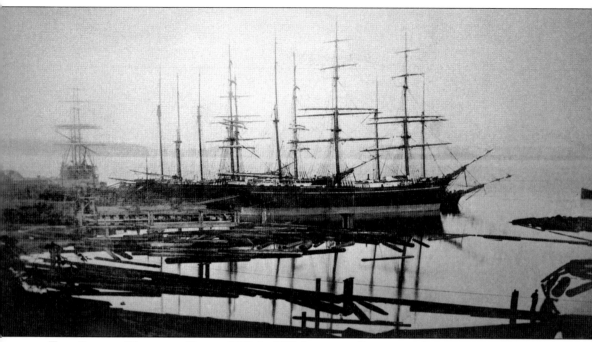

TALL SHIPS IN UTSALADY BAY, C. 1878. In 1853, Lawrence Grennan and two partners, Thompson and Campbell, located a spar camp at Utsalady. With axes, it took days to cut the straight, knot-free, 200-foot trees without damage. Grennan and John Izett went to San Francisco to purchase a steam engine, boiler, and saws to start a mill at Utsalady Point. On the trip to Puget Sound, the machinery was thrown overboard when the ship met the rough seas passing the Columbia bar. Meanwhile, in 1855, with the permission and assistance of some Kik-ial-lus men, the first load of Douglas fir spars was logged from Utsalady by Thomas Cranney, who had bought an interest in their venture by then. In December of that year, the *Anadyr*—a barkentine bound for Brest, France, and captained by Whidbey Island's Captain Swift—took the first shipment from Utsalady. A year later, a second load of 100 spars was taken to Holland on the *Williamsburg.*

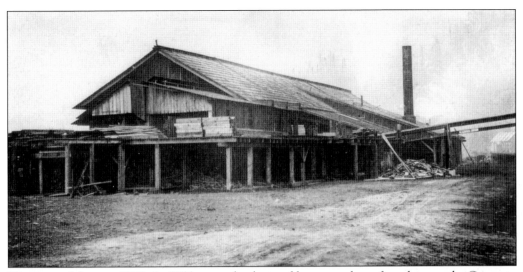

UTSALADY MILL, C. 1878. In 1856, not to be deterred by a mere loss of machinery, the Grennan and Cranney Company formed. They built a 600-foot by 100-foot mill building with a boiler engine and vertical saws. It began operation in 1858 and paid off the mortgage that financed construction with a shipment to Shanghai.

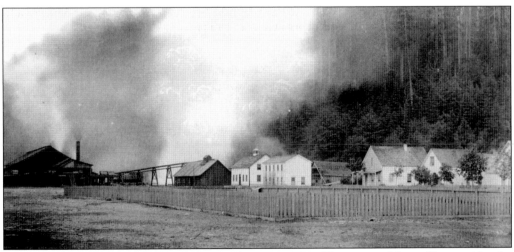

UTSALADY MILL WITH SAWDUST REFUSE FIRES, C. 1878. The noise of the mill was said to be tremendous, and smoke from the fires was always present. Sawdust, wood slabs, and shavings was taken from the machines by a 175-foot-long slab conveyer to the slab fire. The buildings to the right of the mill conveyor are the blacksmith shop, the cookhouse, the "bummers" hall (rooming house for mill men), and residences.

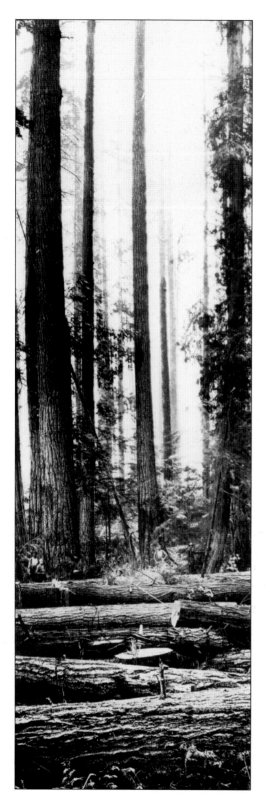

OLD-GROWTH TIMBER. This photograph, taken about 1920, shows the size of some of the timber on Camano Island. The trees were so tall and immense that ship captains were afraid to bring their ships too close to shore for fear of having the mast riggings caught in the trees. In 1860, a load of 402,000 board feet was shipped to Chile, and a more typical load of 76,000 board feet was shipped by schooner in 1861. That year a correspondent reported that he "witnessed, with sorrow, the cutting of large port-holes in the noble ship the *Indiaman*" to admit the huge spars, 38 inches in diameter, for the Spanish naval station near St. Ubes. In 1867, a log to be used as a flagstaff at the 1867 Paris World Exposition was 24 inches at the stump, 11 inches at the top, and 200 feet long. It had to be cut to 150 feet so the ship, the *Belmont*, could carry it.

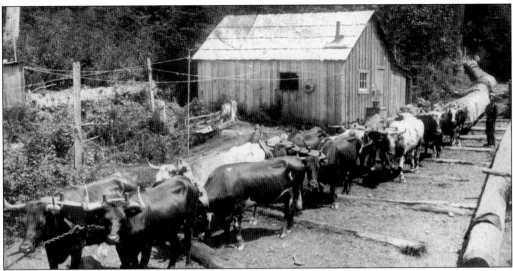

OXEN TEAM AT UTSALADY, C. 1883–1886. This is an oxen team hauling large fir logs along a skid road to the mill at Utsalady. The driver of the oxen was called the bullwhacker, or puncher. Until the 1880s, before two-man crosscut saws were used to fell a tree, only axes were used. The skid road logs were greased with dogfish liver oil and the front of the logs being hauled were sniped (rounded) so they would slide over the skids. (Photograph by Dorsez and Schwerin, Photographers.)

J. B. LIBBY. Built in 1862 by Hammond, Calhoun, and Alexander, the 70-ton side-wheeler was launched at Utsalady and used by different owners until 1865. It carried passengers and the mail two times a week between Seattle, Coupeville, Utsalady, Swinomish (LaConner), and Whatcom. (Courtesy Puget Sound Maritime Historical Society, Negative 378.)

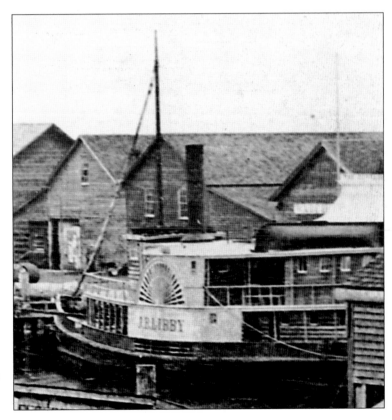

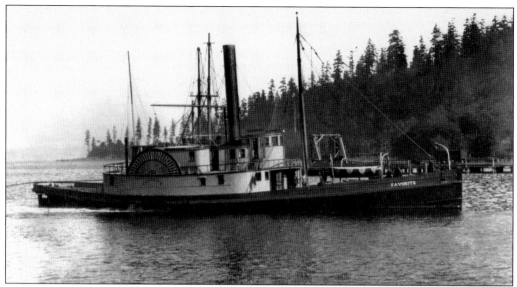

SIDE-WHEELER STEAMBOAT *FAVORITE*, BUILT AT UTSALADY, **1869**. Between 1861 and 1873, nine vessels of various types were built at Utsalady: a two-masted schooner called *Sarah*; a sloop named the *Mary Ellen*; side-wheeled steamer, the *J. B. Libby*; a cutter refitted as the *Gov. Wallace*; the steamer *Cascades*; the steamer *Success*; the steamer *Linnie*; and a 452-ton barkentine, the *Modoc*, built by George Boole. (Courtesy Puget Sound Maritime Historical Society, Negative 952.)

UTSALADY MILL,

(ESTABLISHED, 1858)
WASHINGTON TERRITORY.

Proprietors, GRENNEN & CRANNEY.

LUMBER AND SPARS,

Of the finest character, shipped to all parts of the world.

SHIPPING ORDERS PROMPTLY ATTENDED TO.

UTSALADY MILL ADVERTISEMENT, PACIFIC COAST BUSINESS DIRECTORY, **1867**. In 1869, Grennan died while on a business trip to San Francisco; Cranney eventually bought out his interest from Grennan's widow. Tragedy struck again in 1875. On November 4, the side-wheeled steamer *Pacific* sank, killing an estimated 275 people in the worst shipping disaster in the United States up to that date.

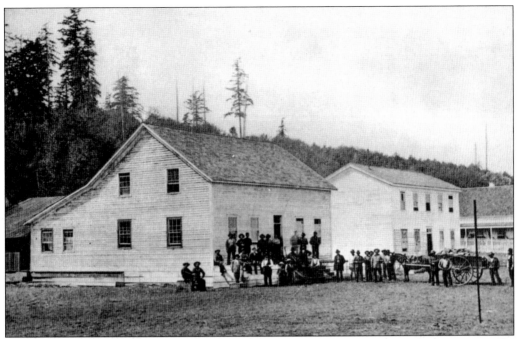

MILL MEN IN FRONT OF COOKHOUSE; BUNKHOUSE (BUMMER'S HALL) ON RIGHT, C. 1878. The *Pacific* collided with the square rigger *Orpheus* off Cape Flattery on its way from Victoria, British Columbia, after picking up passengers, sacks of grain, horses and buggies, and other tonnage in Puget Sound, some of which was from Utsalady. Colin Chisholm, manager and possibly an owner of partial interest in the mill, was on the *Pacific* carrying funds for mill debts.

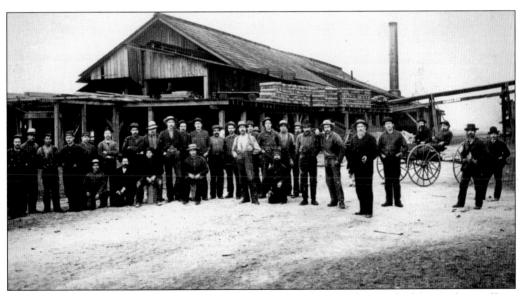

MILL MEN IN FRONT OF UTSALADY MILL, 1880s. This shipping disaster had far-reaching effects on the West Coast, and it is possible to imagine that Utsalady and perhaps Camano Island might eventually have been quite different places had it not happened. A new era began at the Utsalady Mill when the Puget Mill Company purchased it for $32,000 in March 1876.

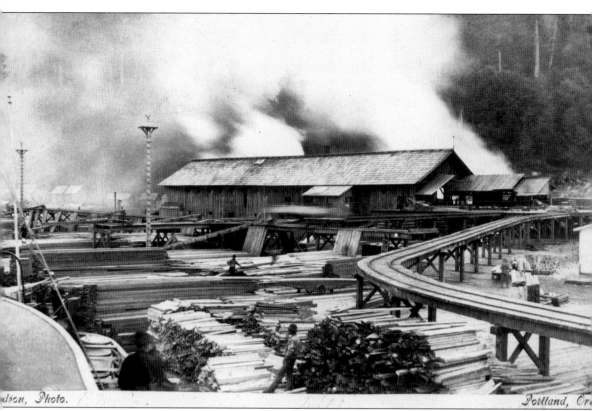

UTSALADY MILL WITH RAILS TO LOAD SHIPS, 1880S. For the next 15 years, Cyrus Walker managed and modernized the mill, though he usually worked from the Puget Mill headquarters at Port Gamble. According to E. G. Ames, when the mill was operated by Puget Mill it was capable of cutting logs up to six feet in diameter and up to 75 feet long. The mill had a capacity of 75,000 feet per day and employed about 45 men. It also had a lath mill and could produce 10,000 laths per day with a crew of four men. The smoke in the background obscures the view of the hillside. Note the fire towers. This image shows how lumber was distributed over the dock from an elevated railroad from cars eight feet above the wharf. The lumber wharf had frontage of 430 feet.

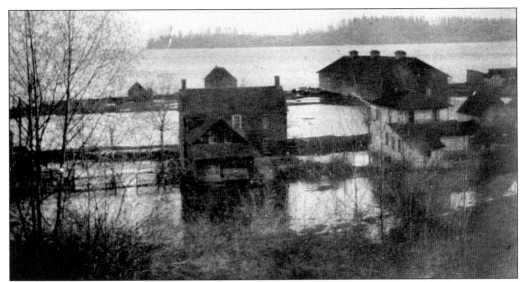

FIRST SCHOOL BUILDING. In the distance along the shoreline (second building from the left) is the first school building; on the right is the granary. Note Brown's Point in the distance. Utsalady's first school (Island County District No. 5) was established in 1862 by Grennan and Cranney. The school building is visible above the roofline of the Grennan and Cranney house (with the two chimneys).

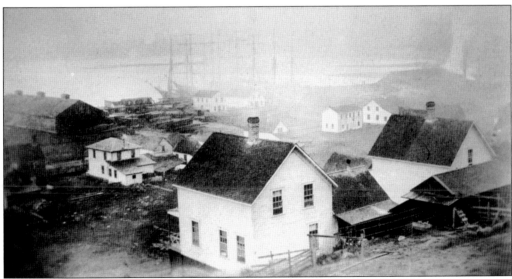

UTSALADY HOUSES, MASONIC HALL, AND TALL SHIPS, 1880s. Though faint, this photograph shows the tall ships, the mill building, and the back of some of the residences from the hillside. The two-story building just in front of the tall ships along the shoreline is the Masonic hall, established in 1872. It was called the F. and A. M. Camanio Lodge No. 19 in reference to the Spanish pronunciation of the name of the explorer Don Jacinto Caamano. In 1890, the order moved to Stanwood.

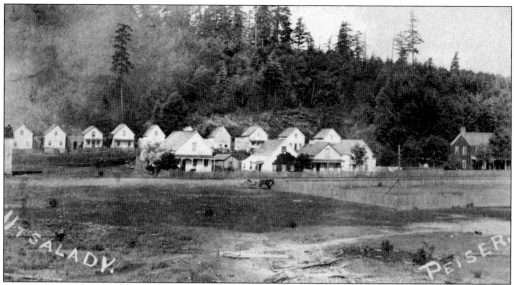

RESIDENCES OF UTSALADY, C. 1883–1885. This view shows Deer Park surrounded by a picket fence, the row of mill worker cottages behind, and the logged-off hillside at Utsalady Point. After the Puget Mill Company took over, properties were rented out by the mill company. People who wanted to farm spread out toward the Stillaguamish or Skagit Valleys.

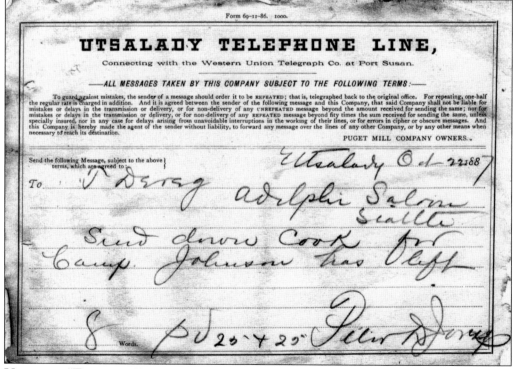

UTSALADY "TELEPHONE" LINE CONNECTING WITH WESTERN UNION TELEGRAPH COMPANY AT PORT SUSAN. In 1864, the telegraph line went from Seattle north, with a branch connection from Port Susan, out to Utsalady. This telegraph message, along with 43 others sent between October 18, 1887, and October 24, 1887, was saved by the Olsen family.

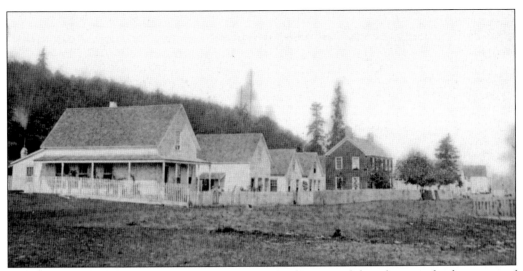

PICKET FENCES ON FRONT STREET, UTSALADY. At the time of this photograph, the names of those who lived in the houses, from left to right, were J. Hicks, the mill engineer; Nels D'Jorup and family, ferryman and later saloon and hotel keeper; Ed Hickman; Captain Gaither, and Thomas Cranney in the two-story, dark-colored house with two chimneys. Beyond the trees was the dance hall and saloon—"a notorious place."

UTSALADY HOTEL. This is one of the Utsalady hotels, possibly operated by the D'Jorups. Peter, his brother Nels, and their families were some of those who lived at Utsalady for an extended period. Peter D'Jorup was also active in buying and selling land in Island County and served as county commissioner from 1874 to 1887.

Utsalady Wash Sept 9, 1908.

19

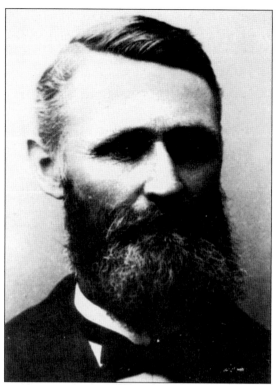

THOMAS CRANNEY OF COUPEVILLE AND CAMANO ISLAND. Cranney left Camano and moved back to Whidbey in 1877, when his personal holdings were sold to cover his losses from the disaster not covered by insurance. The shipwreck must have been a devastating setback, yet he continued to serve Island County over the years as commissioner, auditor, treasurer, and representative to the Territorial Legislature.

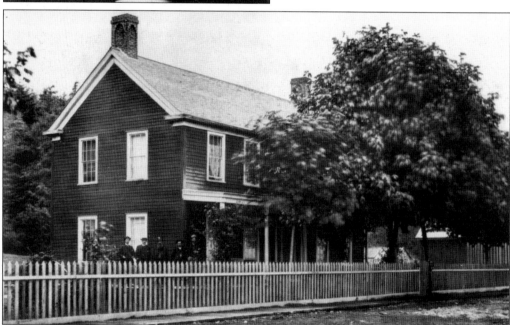

CRANNEY HOUSE. Notably the largest house on the property, the brown house with the two chimneys was the residence of Grennan and Cranney and their families. The house is reminiscent of the Eastern seacoast homes where both men were from. After Cranney sold it to Puget Mill as part of the bankruptcy agreement, one side was used by A. H. Pratt, the mill superintendent, and his wife. Cyrus Walker, the mill manager, lived in the other side when he was there on business.

Following is the lumber cut of Puget Sound and the state as compiled by the Seattle *Post-Intelligencer*, from December 1, 1889, to November 30, 1890:

THE LUMBER CUT OF PUGET SOUND.

	Lumber,	*Lath, etc.*
Washington mill	22,391,000	7,200,000
Port Madison mill	21,116,000	5,429,000
Port Discovery mill	31,035,521	10,906,400
Puget Mill Co., Pt. Gamble	28,432,655	8,999,790
Puget Mill Co., Ludlow	21,051,144	9,069,523
Puget Mill Co., Utsalady	25,799,585	7,808,118
St. Paul & Tacoma mill	48,990,415	7,572,000
Gig Harbor Lumber Co	19,575,269	6,979,175
Tacoma Mill Co	70,538,453	28,322,800
Port Blakeley Mill Co	69,000,000	28,000,000
Thirteen mills in Seattle	192,600,000	23,000,000
Local mills in Tacoma	107,300,000	13,200,000
Bellingham Bay mills	55,000,000	8,200,000
All other mills	64,500,000	9,500,000
Total Puget Sound mills	779,330,042	174,186,806

LUMBER CUT OF PUGET SOUND, 1890. In 1891, the mill stopped running. The closure was thought to be temporary because of the need for upgrading. (Figures from *History of Seattle, Washington*, American Pub and Engraving Company, 1891.)

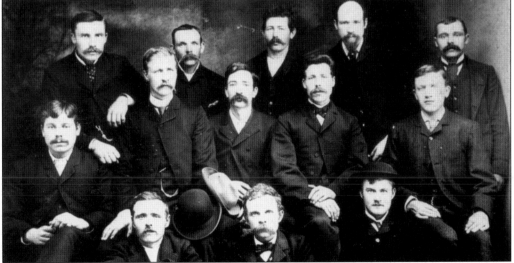

MILL MEN FROM UTSALADY, C. 1890. The occasion for this photograph is unknown, but many of those pictured went on to hold prominent places in the community. Pictured, from left to right, are (first row) Sivert Johnson (farmer and carpenter), George Billings, and Joe Estergreen (farmer); (second row) John Einarsen (head sawyer at Stanwood Lumber Company), Ole E. Heggen, John Dougherty, Knute P. Frostad (farmer and Island County commissioner, 1896–1902), and Knute Foremoe; (third row) John Hals (Florence, WA mill owner), John Anderson, Knute Larsen, Pat Morrisey, and John Sorenson.

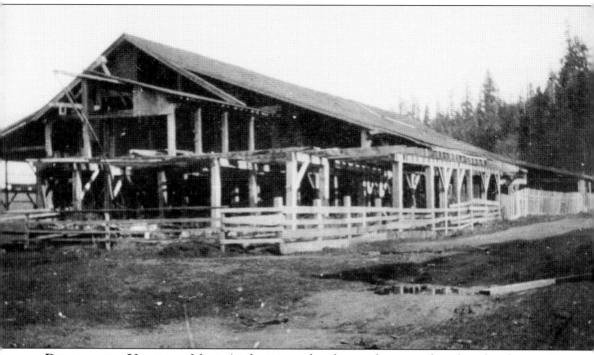

DISMANTLING UTSALADY MILL. At the time, other factors that contributed to the closure of the mill included the fact that the railroad went through Stanwood in 1891 on the mainland and began to change transportation patterns. From the perspective of the Straights of Juan de Fuca and international trade, Utsalady was not a convenient port. In 1893, a bank panic caused a depression that the country did not rise above until the Klondike gold rush in 1898. The mill building stood idle and the machinery was either removed to other mills owned by the Puget Mill Company or sold. By 1909, only the mill (constructed with wooden pegs, not nails), wooden wharf, blacksmith shop, hall, hotel, and a house were listed as property of the Puget Mill Company. A fire took the hotel in 1906, and the mill building was taken down in 1916.

Two

Logging, Log Booms, and Shingle Mills

The 1890s were a slow decade for logging or any activity on Camano after the Utsalady Mill closed. But demand for logs slowly began to pick up around 1900 with improvement of the economy after the Panic of 1893 and the Klondike gold rush. From 1900 into the 1920s, there were 10 to 20 logging camps active on Camano Island at various times, taking logs from school lands and lands often owned by speculators. Because logging was hard and dangerous, workers were struggling for better and safer conditions. Camps started up, shut down, moved around, and changed owners. Small crews, with oxen in the early days and later horses and trucks, hauled logs to a centralized location to be taken by water or truck to the mills.

Much of the Western red cedar had been left behind in the first cuts. Its value increased and five steam-powered shingle mills started production on the island. It was a source of cash income for many farmers. There was a shingle mill located on Davis Slough below Land's Hill known as the Becker Mill. At New Utsalady, there was a mill known as Jack Brown's Mill. At Elger Bay, a mill was operated by Andrew Shervin from about 1902 until 1910. A mill, started at Camano "City" in 1904, was operated by Van Cleve and Sons until 1910. The Triangle Shingle Company started at Triangle Cove about 1906 and ran until about 1918.

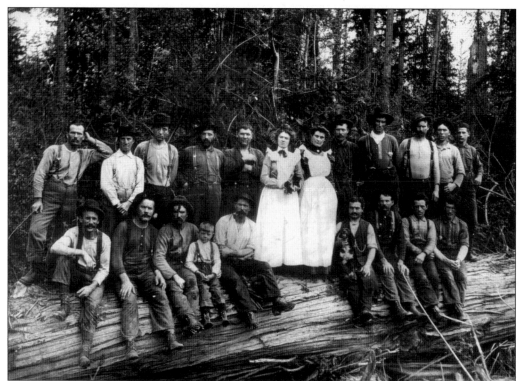

PEOPLE ON A FALLEN CEDAR TREE. The logging crews were usually provided with bunkhouses and meals while out in the woods. This is the Joe Ferguson camp crew, including women, hired to cook and serve meals. Ferguson started logging on Camano about 1902 with Ed O'Melia (center) as his crew boss until 1905.

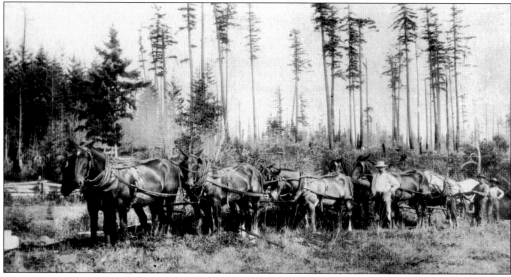

TEN-HORSE LOGGING TEAM. The Hogan Brothers proudly display their team of horses with a stand of trees in the background. They operated one of the early small logging camps near Livingston Bay and Triangle Cove. The Hogan brothers, Jack and Walter, along with their father, lived in Stanwood and logged on Camano until about 1905.

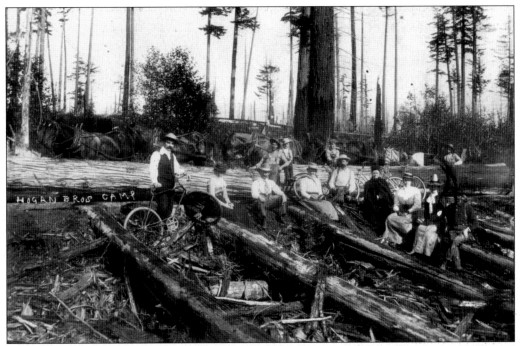

HOGAN BROTHERS CAMP. Visitors visit the camp on bicycles. The logs in the foreground formed a landing where they were rolled to the water. The trees were bucked into 32-foot lengths and the bark was peeled to make it easier to skid.

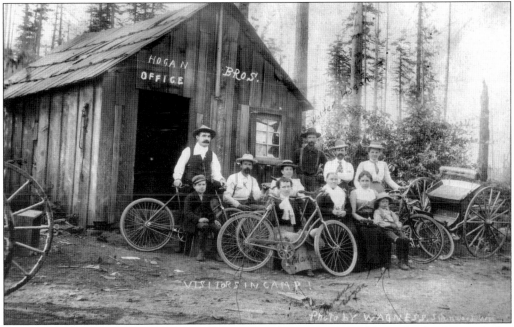

VISITORS IN CAMP. The same Hogan family members are pictured here. In the foreground is Alice Hogan, wife of one of the Hogans. Jack Hogan is in the white derby. Walter Hogan is in back standing in the middle. The rough roads would have made it a difficult ride from Stanwood in the buggy and on the bicycles.

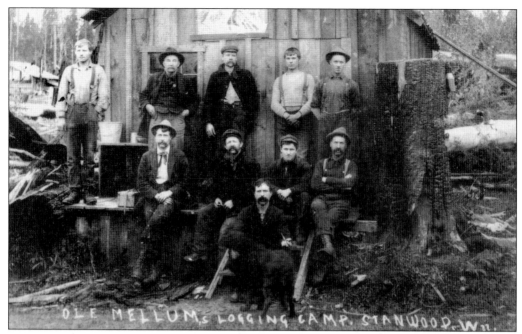

OLE MELLUM'S LOGGING CAMP, C. 1907. This photograph by John T. Wagness shows Ole Mellum seated on the left. The others are unidentified. In March 1907, the *Stanwood Tidings* reported that Ole Mellum "started his logging camp at Joe Heal's Bay."

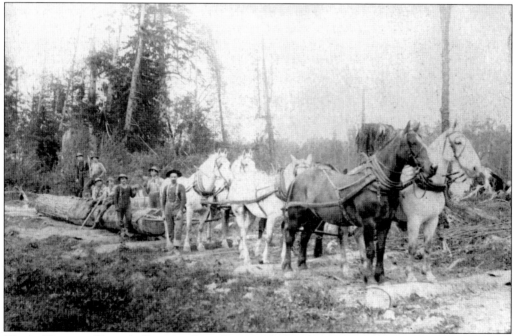

HORSE TEAM AT TERRY'S CORNER. For a few years before the donkey engine was invented, horses replaced oxen for hauling logs to the mills. It was a relatively benign way of logging, leaving much undergrowth and small second growth to seed and succeed. It also left debris to catch fire, which it sometimes did. (Courtesy Don Moa.)

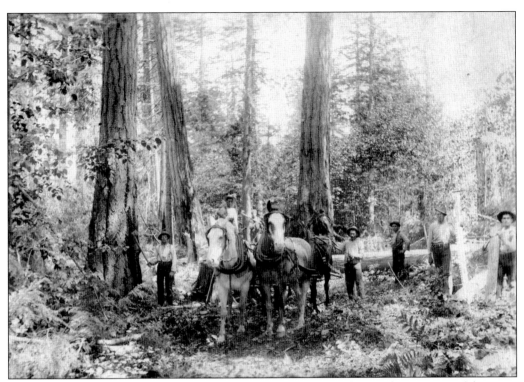

HORSE LOGGING. The deeply fissured bark of the Douglas fir indicates the maturity of the trees, even though they are not as big around as some of the prize specimens in other photographs. On the right are Camano Island loggers holding their crosscut saws and springboards.

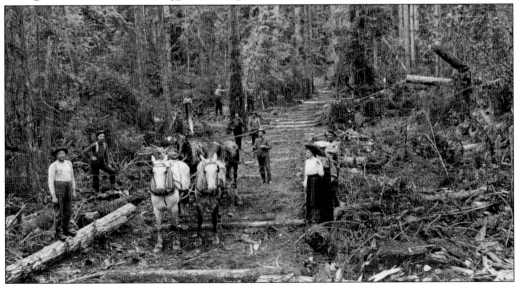

TEAM PREPARING TO HAUL A LOG. Note the block rigged or "choked" to the tree to haul or "yard" the trees to the skid road. This work would soon be replaced by a donkey engine. Lines were made of hemp with a wire core. If rigged incorrectly or if it snapped, they often caused serious accidents. In the background on the left is a man standing on the springboard. It was no doubt a special occasion to have female visitors with such lovely hats to camp.

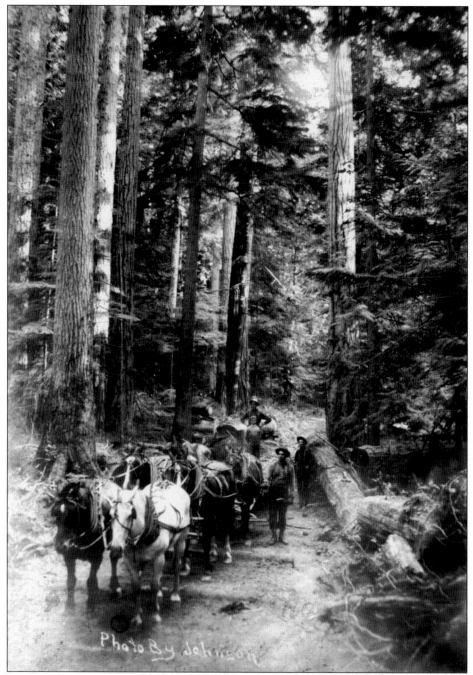

Photo By Johnson

MAJESTIC STAND OF TREES. This skid road ran through a stand of Camano Island trees. The driver on the right manages the team along the skid road—a difficult job with oxen or horses (even though horses were much stronger than oxen). The driver was one of the highest paid on the crew. This is classic hand logging—trees are felled with axes and crosscut saws as close to the skid road or water as possible. Fallers were careful to take trees that could land downhill wherever possible to avoid being shattered. Jacks were used to raise and free the tree from the place it fell. Bucking the logs was dangerous because once cut, they could easily roll over on a logger.

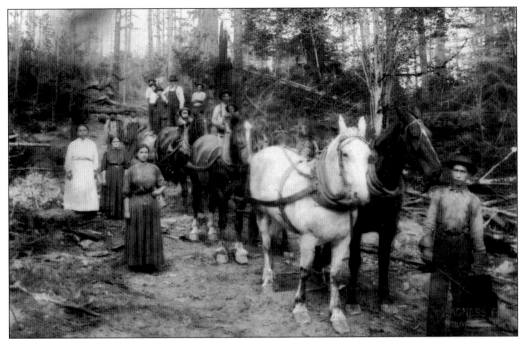

WAYNE PROPER'S LOGGING CAMP. Wayne Proper sits on his horse with his young son in his lap. Many of the loggers were Native Americans as in this family. Sally Oxstein is in white on the left. In front of her is her daughter Lillian. Tom Oxstein is on right with the dogfish oil bucket to grease the skid logs.

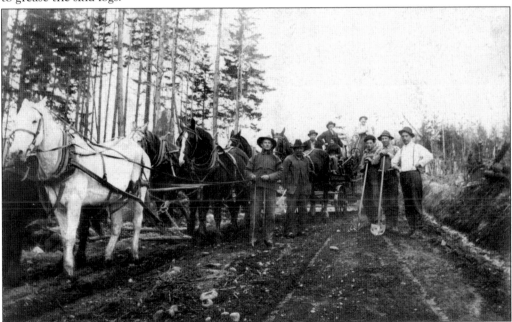

ROAD BUILDERS. This six-horse team pulls a grader used to scrape and level the roads. It is difficult to tell whether this is a logging road or perhaps an early wagon road. Earlier roads were built with horses and a slip scraper, which looked like a large wheelbarrow. It was a much more unwieldy tool, dragged by a horse and used to scoop the soil to dig the roads.

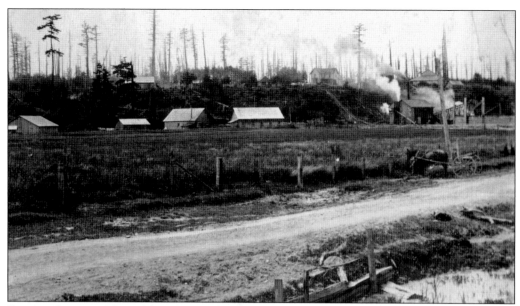

BECKER SHINGLE MILL. Along Davis Slough, which passes between Leque Island and Camano Island, was one of the early Camano shingle mills. Note the chute that carried the bolts down the bluff. This mill was located north of the Land's Hill base. The dirt road in the photograph is on the same farm road that turns off the highway now. Before the 1930s, the road switchbacked up this hill but was straightened when it became Secondary State Highway I-Y, now State Route 532.

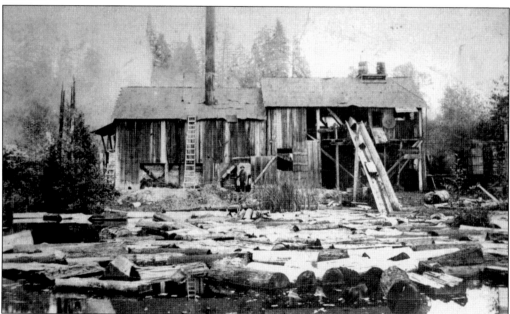

SHINGLE MILL AT NEW UTSALADY. Around 1914, Jack Brown came to Camano Island and took over the shingle mill near what is now Gerdes Road. Note the bolts in the pond in the foreground and the log chute. Brown provided lumber for the Utsalady Ladies Aid building that he constructed for them in 1923 and for his house that is still located on the beach on the east end of Utsalady Road.

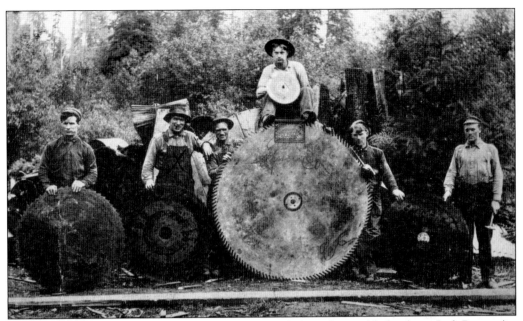

AVONDALE SHINGLE COMPANY. According to the label on the saw blade, this is Jack Brown (in overalls) and his shingle mill crew. The mills were often referred to by the name of the manager or operator and the official name changed when the owners changed. In this case, it is not really known whether Brown was the owner or the manager of the mill. Jack Brown also served as Island County commissioner from 1926 until 1931.

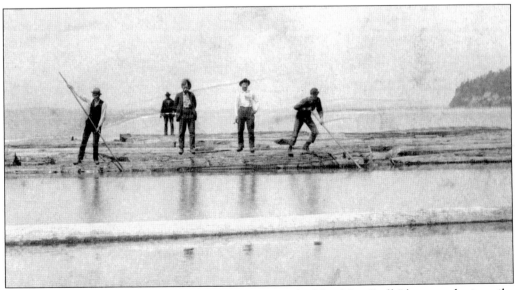

BOOM MEN AT UTSALADY. These men are wearing spiked "cork" or "calk" boots and using pike poles to arrange the logs. The logs might be for use at the mill or they might be boomed waiting for a tug to haul them to a more distant lumber mill. In the distance is Brown's Point.

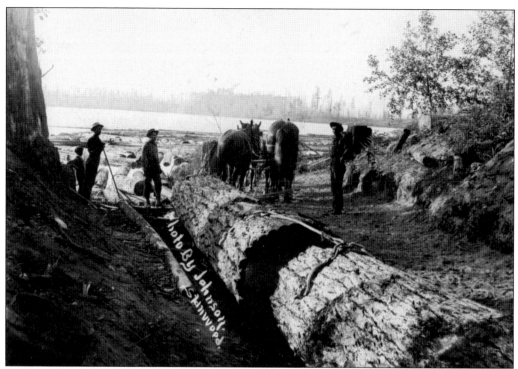

Hauling Logs to Shoreline. This *c.* 1909 photograph illustrates how the logs were hooked together. The logs were boomed up along a Camano Island shoreline until there were enough for a load to be taken by tugboat to the mills.

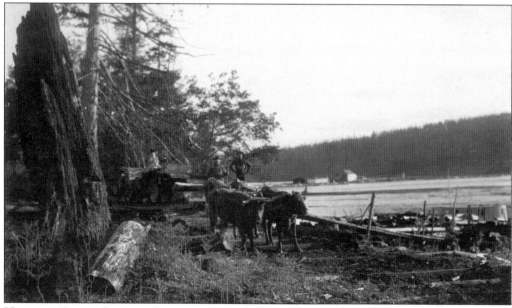

Hauling Cedar Shingle Bolts on Barnum Road, c. 1910. Sterling Barnum, who owned a large farm west of Livingston Bay, is pictured here using oxen to haul logs and cedar shingle bolts on a sled. In the background, note the shingle mill across Triangle Cove on the spit now called Driftwood Shores. (Courtesy Patricia Guitteau.)

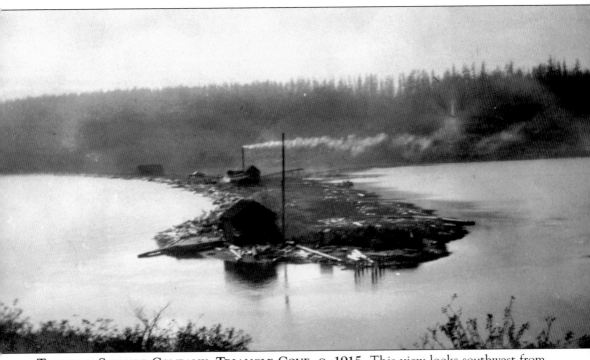

TRIANGLE SHINGLE COMPANY, TRIANGLE COVE, C. 1915. This view looks southwest from Barnum Point toward the spit now called Driftwood Shores. Note the absence of spartina, and the wider channel. The shingle company was operated by Rasmus Konnerup and his son Nels. They employed about 20 men in the mill and about 20 men in the woods. An advertisement in the *Timber Workers Employment Guide* in 1915 said this mill had four upright shingle machines, "Triangle Shngl Co. Nine Miles out. Joe Heel's Bay. Wagon Road, Was Steady; idle now. Cut bolts. Emp. 18. Good board. Bunks rough. Pay any time. Union wages. Fair to union." Early accounts often refer to a place called Joe Eel's Bay, which is either another name for Triangle Cove or possibly the larger bay in this photograph outside of the cove. The name is curiously specific, but no one remembers who Joe (H)Eel was. Perhaps it is named after a fellow listed in the 1860 census named Joe Heal, who was a laborer at the Grennan and Cranney mill. (Courtesy Patricia Guitteau.)

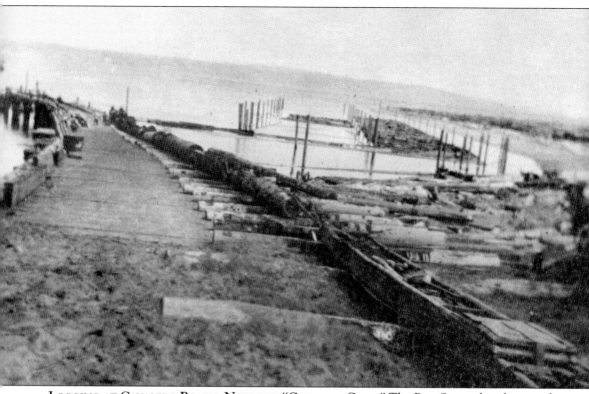

Logging at Cavalero Beach, Now the "Country Club." The Port Susan shoreline south of Joe Eel's Bay was known as Cavalero Beach because Dominic Cavalero logged property along and above that shoreline. This crew is from the Esary Company. The view shows the wharf built out from the spit that took advantage of a shallow place to boom, section, and sort logs. The men and horses in the distance are at the head of the chain of logs that were pulled down the skid road to be dumped and await the tugboats. At the end of the chain is a raft-like "pig" that carried tools and buckets and one or more of the crew to keep logs from snagging. This spit later formed the country club lagoon. There is now a small county park and boat launch that is just north, called Cavalero Park. A 1901 *Island County Times* article describes a forest fire at Cavalero's Camp that "entirely destroyed all equipment except the donkey engine which was hauled down to the beach. The fire approached the camp while the men were asleep and gained such headway that all efforts to check it proved useless."

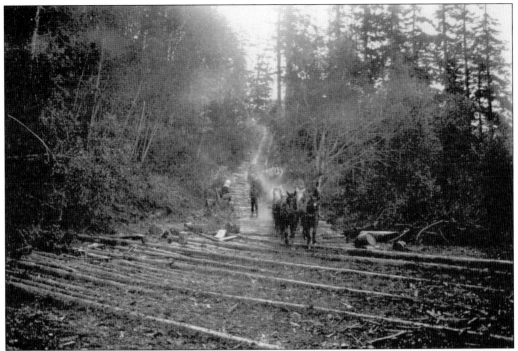

SKID ROAD TO CAMA BEACH. Those who have spent time at the former Cama Beach Resort, now a state park, will recognize the slope of this logging road to the landing that would become Cama Beach. This logging crew was Tom Esary's, who owned 300 acres of land and operated a logging camp there from 1905 to 1908. (Courtesy Amaryllis Whitmarsh.)

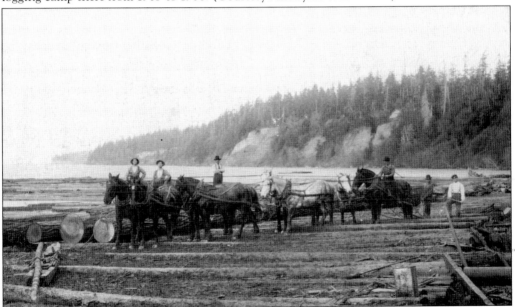

SKID ROAD LANDING. This photograph of the Esary Logging Camp crew and horse team looks in the opposite direction from the photograph above. The skid road built on the shoreline created a level spot to put the logs into the water. Note the bluffs in the distance, north of Cama Beach. (Courtesy Amaryllis Whitmarsh.)

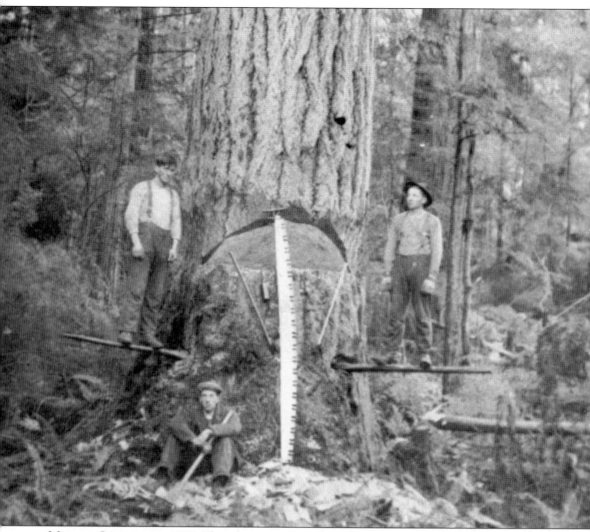

Mabana Logging, c. 1915. These loggers were working for Nils "Peg Leg" Anderson, who logged the south end of Camano around Mabana. Standing on springboards anchored into notches of a large tree made it easier to cut the tree. The back cut has been made and crosscut saw will now be used to cut it down. Swante Kyllonen (left) became known as a skilled high rigger who demonstrated cutting spar trees and rigging at fairs. About 1911, Nils Anderson's camp was operating at "Cox Spit," or Pebble Beach, south of Mabana. He used a steam donkey with "fore and aft" skid roads leading inland a half-mile or more in several directions according to John R. Metcalf (in *Of Life and Living In My Time*, 1984). In 1916, Anderson moved his camp to Utsalady.

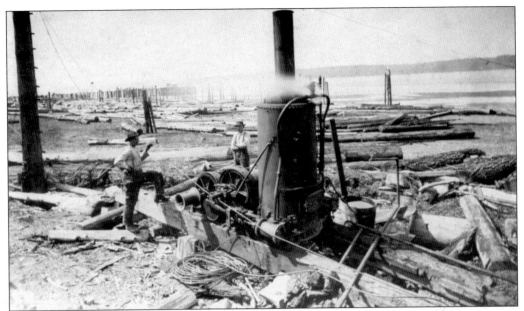

DONKEY ENGINE ON BEACH. Dolbeer donkeys were steam-driven engines geared to a capstan or drum rigged to skid or haul logs to the shoreline or railroad landing to be taken to the mills. This machine replaced some of the work of the horse or oxen. This photograph is thought to be Utsalady or possibly the Island (English) Boom.

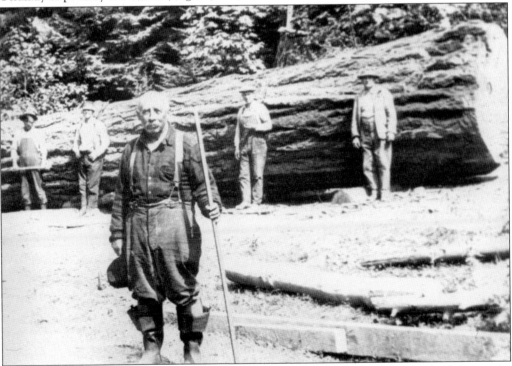

ED CLAY AND LARGE DOUGLAS FIR. In 1920, when John T. Wagness came to Utsalady to take this photograph, there were only a few stands of trees left with logs as huge as this one. As this photograph shows, there were still a few logs harvested by a team of horses across skid logs.

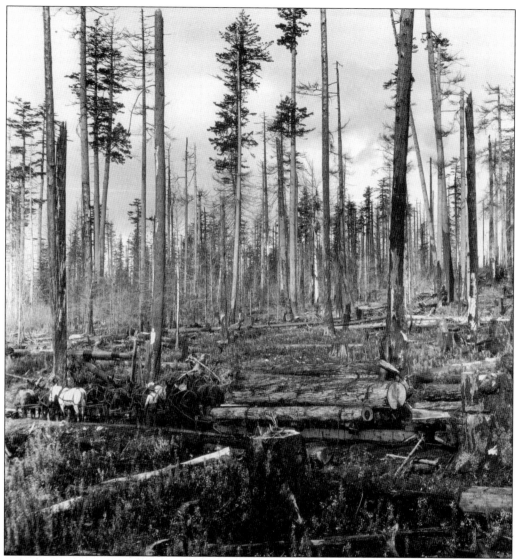

ESARY'S LOGGING CAMP NO. 2, OCTOBER 1920. Logging camp No. 2 was probably Madrona. Horses are hauling logs on skids out to the shoreline where they will be boomed up and hauled to mills. They would buy some land or pay stumpage and sell the logs to the mills. The size of the photograph does not do justice to the size of the timber dramatized by the small figures in the image. Note the fire damage on some of the trees. (Photograph by Darius Kinsey, No. 9419.)

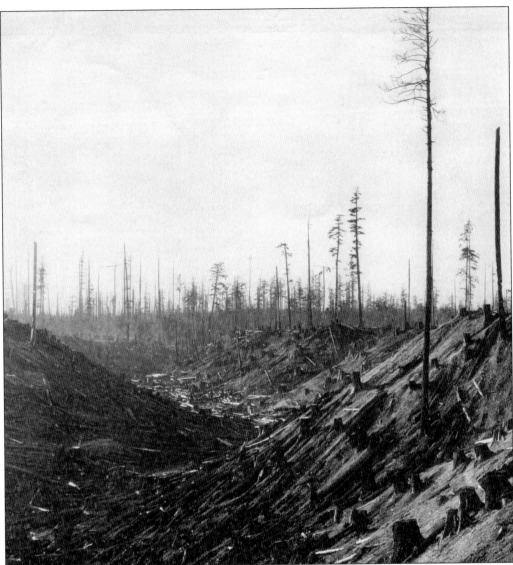

ESARY CAMP NO. 1. On August 16, 1920, a $40,000 fire swept through this canyon. An educated guess places the fire in the gully along what is now Chapman Road. Numerous fires damaged the timberlands of Camano Island from the 1860s on. Some were deliberately set to burn slash. If the fires were in a particularly dense cutover area, the fires could be hot enough to destroy the thin soils, changing the forest ecology for regrowth. Large companies, such as Puget Mill, patrolled and tried to protect their timber investments, but surrounding lands were often abandoned and not so carefully tended, nor were they replanted. (Photograph by Darius Kinsey, No. 9422.)

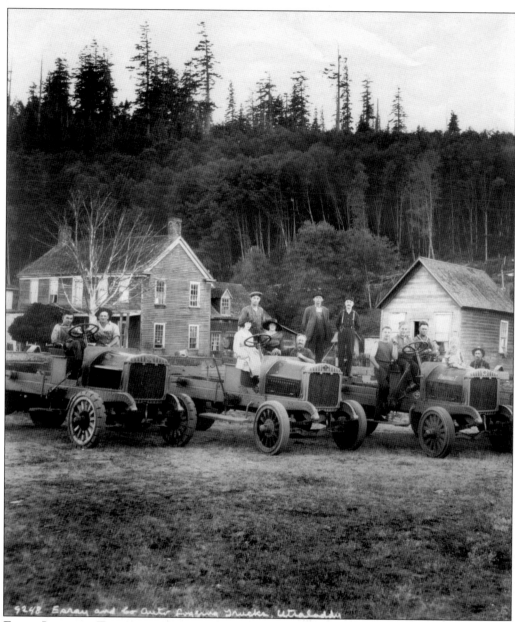

ESARY LOGGING TRUCKS, C. 1920. In this view are early Diamond T logging trucks with hard rubber tires at Utsalady Point. According to the writing on the photograph, the owners are the Esarys, who logged on the island as the Camano Commercial Company until the company dissolved in 1927. In 1902, the Camano Commercial Company was incorporated, with James and Andrew Esary listed as the trustees. Two years later, the Camano Land and Lumber Company was started, with A. J. Esary, F. M. Duggan, and Alpheus Byers as trustees. Both companies, registered in Seattle, invested in the land, logged it, and then sold off parcels. In the background is the Cranney house during the days of the Utsalady Mill (seen in chapter one photographs). (Photograph by Darius Kinsey, No. 924.)

LOGGING THE LAST CLUSTER OF OLD GROWTH, C. 1922. By 1922, only one significant patch of old growth trees remained on Camano Island near Rocky Point. Wesley Norgaard, a skilled high rigger, was hired to top this tree to be used as a spar at Ole Lervick's Camano Island Logging Camp. The spar tree was rigged with blocks and lines that hoisted logs to the landing below, where they were put on trucks. It was dangerous work but more efficient than hand logging. (Photograph by Reverend Bjur; courtesy Jeffrey Pearce.)

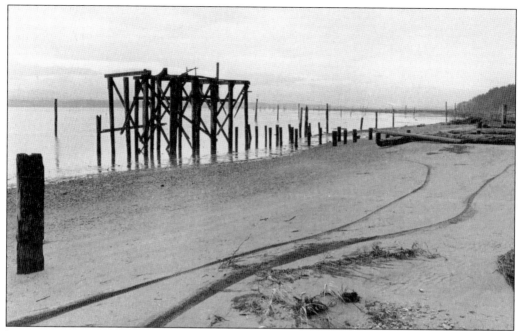

REMAINS OF ISLAND BOOM, ALSO KNOWN AS ENGLISH BOOM. In about 1922, the English Lumber Company had several logging camps that were connected with an elaborate series of logging railroads in the foothills east of Stanwood and Mount Vernon. They dumped their logs into the Skagit River and floated them across the Skagit Bay to the "Island Boom." This 1972 photograph shows the remains of a platform that held a huge elevated oil tank, 10 feet wide and 50 feet long, with the pilings in the distance. (Photograph by Howard Hansen.)

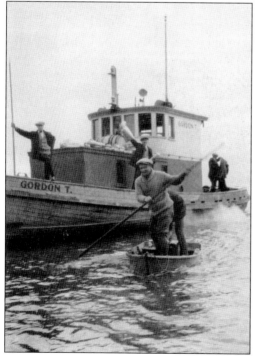

GORDON T. A small tug called the *Gordon T* was built for the boom company to "juggle" the logs around. It was built in Stanwood by local boatbuilder Haakon Matterand. This photograph shows Martin Tjerne, the boom company manager, with his pike pole guiding his rowboat beside the *Gordon T*. The shallow tidelands were dredged to allow the tugboats to rest when not plying the surrounding waters. The *Gordon T* was named for Martin's son Gordon. (Courtesy Elsie Tjerne.)

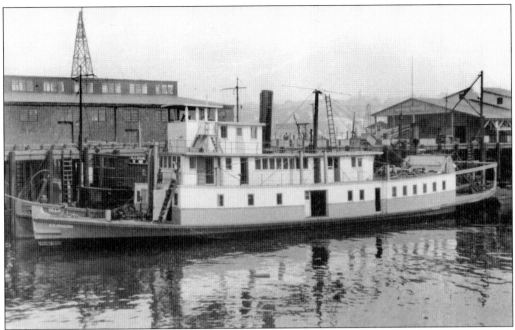

E. G. ENGLISH. In 1928, Martin Tjerne and the boom company purchased the 145-foot passenger stern-wheeler *S. G. Simpson*. Renamed the *E. G. English*, they converted it to use as a tugboat to haul logs to Stanwood once or twice a week. It was fitted with a dredger-type spud (spade or shovel) that helped keep the channel clear for the tugs. (Courtesy Puget Sound Maritime Historical Society, Negative 837.)

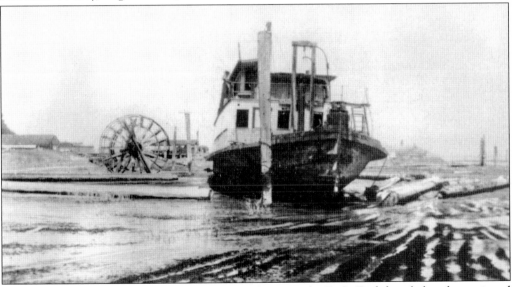

REMAINS OF E. G. ENGLISH. After many years of service, the *E. G. English* ended its days stripped of its machinery and put up on the beach. The hull was later hauled to the Skagit River dike to block a channel. About 20 local men worked the log boom where as many as 15 million board feet of logs waited to be hauled to mills in booms. In 1945, operations ended and the log boom closed when the English Lumber Company was sold to the Puget Sound Pulp and Timber Company. (Courtesy Puget Sound Maritime Historical Society, Negative 837-2.)

PLYWOOD TIMBER. In 1948, a few lone specimens of the old growth remained on the island. They often no longer had tops or were damaged by lightning strikes. One of those left above Utsalady Point was logged by Porter Garrison and his sons after they came back from World War II. They cut it into peeler log lengths, trucked them in their GMC World War II, canvas-top army vehicle to English Boom, and then sent them to the plywood plant in Everett. (Courtesy Bill Garrison.)

TRUCKLOAD SALE, C. 1950. Here are more peeler logs, cut into lengths to be sawn into plywood. (Courtesy Bill Garrison.)

Three

Livingston Bay and Triangle Cove

When the mill at Utsalady closed in 1891, workers dispersed. A few had purchased property on Camano Island near Livingston Bay. They worked to log and clear the land, brought their cows to graze the stumped fields, and eventually built farmhouses and barns. The amount of work involved in removing slash and stumps cannot be exaggerated. Once cleared, most areas, except those in the lowlands, had poor, often burned, and eroded soils. Camano Island never had the agricultural history of the nearby Stillaguamish River delta but, in 1895, milk was delivered to Stanwood when the creamery was established. In 1901, or perhaps earlier, they were also bringing logs to Stanwood to be milled.

Camano was commonly referred to as Crow Island in the 1910s and 1920s. It was a name the loggers called it, noting the large number of crows with perhaps a bit of a derogatory tone. "Uncultivated and unsightly logged off land" was one writer's 1907 description of Camano. The writer hoped that Camano would someday be the home for "seven thousand families in this community who have the proper spirit and desire to someday be "comfortably fixed" on a fine little farm they can call their own."

Livingston Bay, the area where there was the most farming, was named for the first farmer there, Jacob Livingston and his brother David, who filed a homestead in 1862. The last active and productive farming on Camano is still at Livingston Bay on the Nelson and Danielson Farms, both tributes to decades of dedicated agricultural labor.

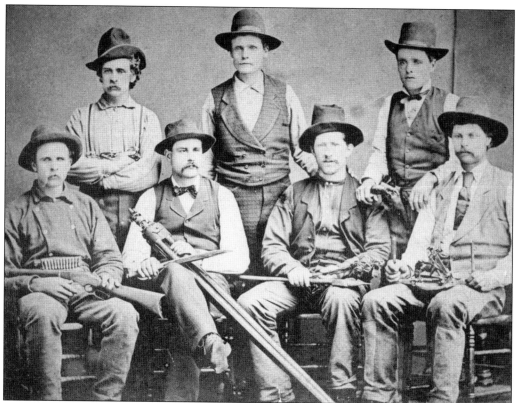

SURVEYORS, C. 1875. When the Utsalady Mill closed, some of the mill men bought farms and settled on Camano Island. This crew includes the men who measured the land on Camano Island and the Stillaguamish River Valley. Pictured, from left to right, are (first row) Sivert Johnson, unidentified, Nels P. Leque, and O. B. Iverson, all influential Norwegian pioneer settlers of Camano Island. The men in the top row are unidentified. (Photograph by Peterson and Bros., Seattle Art Gallery, Washington Territory.)

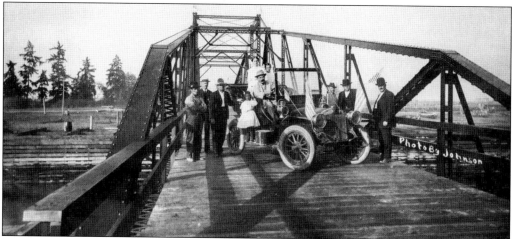

BRIDGE TO LEQUE AND CAMANO ISLAND, 1909. This swing or turn bridge had a tender who lived on the eastern shore. Steamboats, launches, and fishing boats to and from the Stanwood waterfront navigated the pass and channel on high tide.

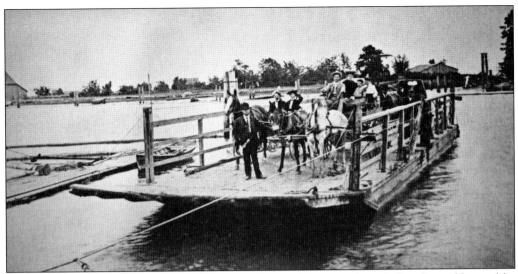

CABLE FERRY ACROSS STILLAGUAMISH RIVER'S WEST PASS, C. 1905. People could travel by horse and wagon, scows, launch or steamers, but regular service was limited. A cable ferry was used to travel to Stanwood for commercial goods, such as milk from Camano farms and lumber for Camano construction and railroad connections. This view looks west toward the Eide barns on Leque Island. The ferry crossed about where the current Mark Clark Bridge is now located.

Bridge Celebration
Stanwood, August 7, 1909

ALLAN BARTZ, Marshal of the Day.

PROGRAM

A. M.

Forming Procession at Odd Fellows Hall, 9:30.
March to the New Bridge.
Selection by Band.
Invocation..REV. W. A. COUDEN.
Address of Welcome..............................MAYOR KLAEBOE.
Selection....................Stanwood and Silvana MALE CHOIRS.
Address by the HON. LESTER STILL, of Island County.
Selection by Band.
Song..AMERICA.
Return March to City Hall.
Noon Hour

1:00 P. M.

Selection by Band.
Song...MALE CHOIRS.
Address..............................REV. W. S. HANLEIN.
Duet..............MR E. A. JOHNSON and MRS. H. A. KENT.
Selection..BAND.
Baseball Game at 3:00 p. m......STANWOOD vs. ARLINGTON.
Purse of $40.00.
Mens', Boys' and Girls' Foot Race, Sack Race, Potato Race.
Tug of War..................Island County vs. Snohomish County.
Walking Greased Pole. Log Rolling Contest.
Fireworks and Grand Ball in the evening. Music by the National Stock Co. Orchestra. Supper at Hotel Stanwood.

DEDICATION DAY FOR BRIDGE, 1909. Finally, in 1909, the bridge over the West Pass of the Stillaguamish River was built, making it possible to drive from Stanwood to Camano Island.

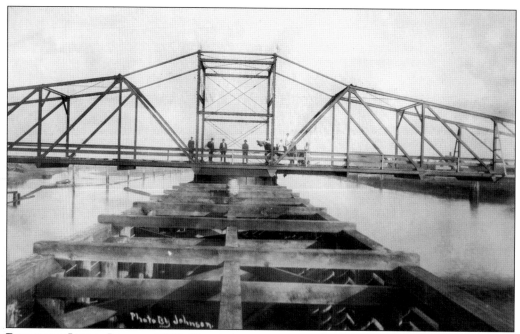

BRIDGE TO LEQUE ISLAND, 1909. The timber structure in the foreground deflected logs coming down the river away from the bridge supports. A bridge tender that lived on the east side of the bridge opened the bridge when a steamer signaled its approach.

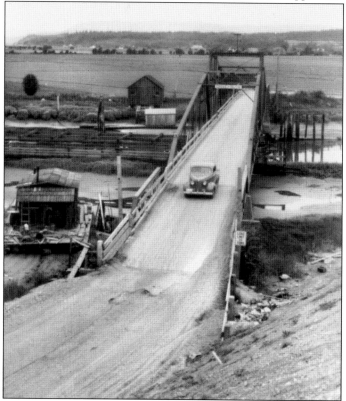

LAST DAYS OF THE OLD SWING BRIDGE, C. 1949. This photograph was taken from the approach of the Mark Clark Bridge as the roadway was being built up with fill to make a higher bridge. The view looks northeast toward Stanwood. In the distance is the Johnson Farm.

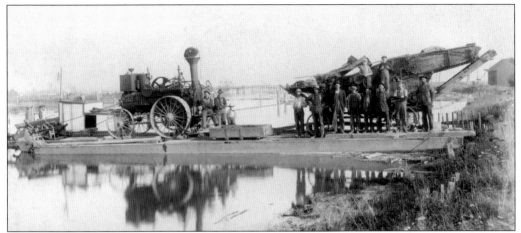

CROSSING DAVIS SLOUGH, C. 1912. West Pass was not the only crossing to get to Camano from the mainland. A 1912 news article described a steel-lift bridge (visible faintly in the background) that would be built across Davis Slough. (Presumably there was some kind of bridge over Davis Slough before this.) The dikes still mark the original width of the slough between the two islands a century ago. In the foreground is farm machinery being brought over to help hay the farm fields. Davis Slough was named for Reuben Davis, who owned land above the southwest section of the slough.

DAVIS SLOUGH GRANARY. This view looks northwest where State Route 532 now crosses Davis Slough to Camano Island from Leque Island. The granary (also visible in the photograph above, looking south), owned by L. T. Land, held hay and oats that were picked up by steamers to be sold in Seattle. Most farms had granaries along the rivers. To the left are buildings that were part of the Becker Shingle Mill.

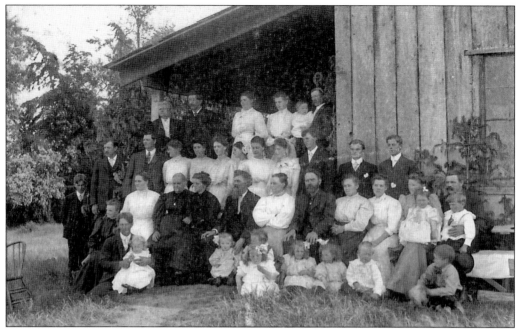

IVERSON FAMILY WEDDING. This is a 1907 wedding of Ed and Lena (Konnerup) Iverson with extended family including Leque, Land, and Konnerup Families. Ed Iverson had a farm on Livingston Bay. Before the roads and bridges were put in they would buy hay and oats in Stanwood. They loaded the grain onto scow that they had to pole across the shallow shoreline of Port Susan to Livingston Bay.

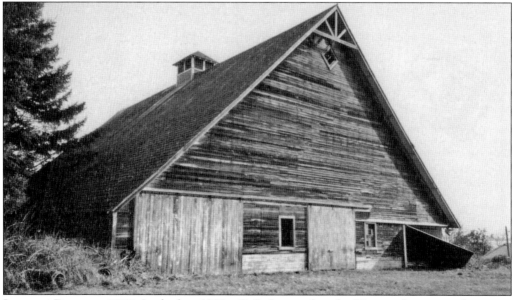

IVERSON BARN, C. 1999. In the late 1800s, O. B. Iverson bought 50 acres that were adjacent to the 90 acres owned by Peter Leque, who diked the land to create the farm fields that are now part of the Iverson Spit Preserve. Around 1903, the land was purchased by Edward Iverson, son of O. B., who took over the farm and built his barn on the bluff around 1913. It was last roofed in 1959 but became too costly to keep up and was recently dismantled.

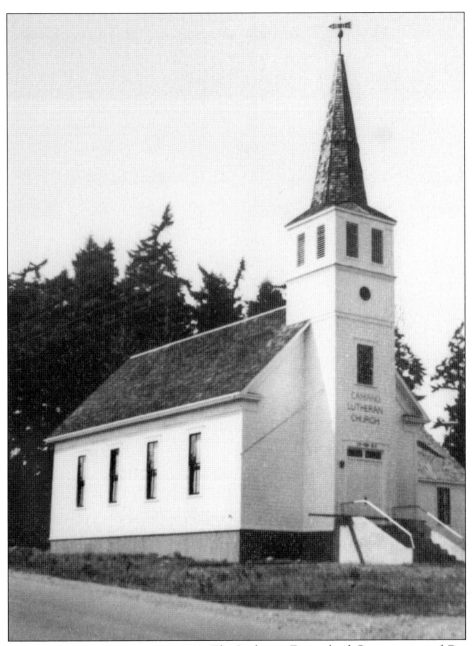

Camano Lutheran Church, c. 1949. The Lutheran Evangelical Congregation of Camano Island was established in 1890. It was originally intended to be located in Utsalady, but the closing of the mill, the severe 1893 Depression, and the fact that most of the members owned land near Livingston Bay probably influenced their decision to build the church where it is now located. Church services were held in the Livingston Bay schoolhouse in 1895 and in Utsalady a few times a year. Religious classes were held for six weeks a year when the school was not used in the winter months. Larson and his son-in-law Sivert Johnson donated the land for the church, and construction of the church building finally began in 1904. It was completed in 1906. Services were given in Norwegian until 1915, and the building was similar to country churches in Scandinavia.

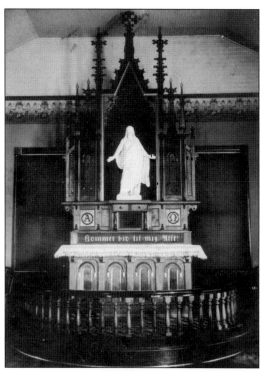

ALTAR OF CAMANO LUTHERAN CHURCH. J. P. Larson was the principal builder of the beautifully carved altar, pulpit, baptismal fount, and hymnal board, with assistance from Knute P. Frostad. Larson used 11 different woods, all received as gifts from captains who shipped lumber from the Utsalady Mill when he worked there.

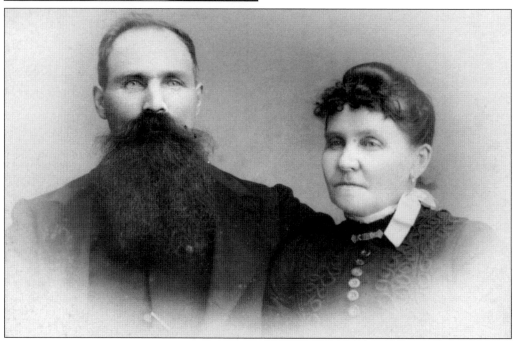

JOHN P. AND ANNIE LARSON. J. P. Larson was a founder and supporter of the church. While the Utsalady Mill was still active and before the church was officially established, services, given by a traveling pastor, were occasionally held at Utsalady Hall and at the homes of Nels D'Jorup or Larson. Larson built his house on his farm across from Livingston Bay Road. After he died in 1921, Sivert Johnson and his family moved into the house.

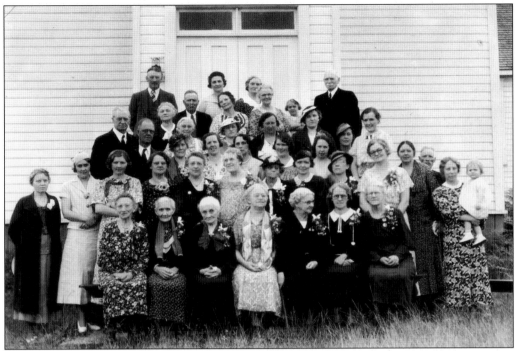

CAMANO LUTHERAN LADIES AID, MAY 27, 1936. The women, pictured here on their 40th anniversary, met informally as a sewing society to raise money for a Norwegian religious school for the children. In 1895, they held an auction that raised $80. After that success, they met at the Thompson's to organize the Ladies Aid. One of their prize purchases was the Kimball pump organ. The Reverends Lane and Ylvisaker are in the upper left.

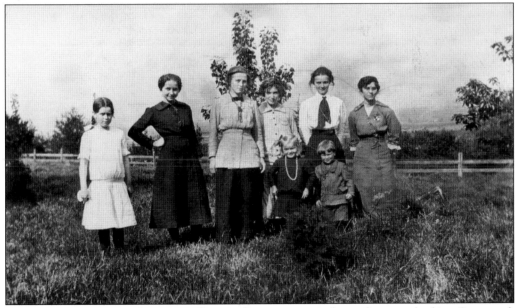

ISLAND GIRLS, C. 1912. Livingston Bay residents are pictured on a farm overlooking Stanwood. From left to right, they are Agnes Einarson, Constance Oksendahl, Adline McKane, Lydia Oksendahl, Bertha Oksendahl, Helen Land, Tinka Oksendahl, and Harold Land.

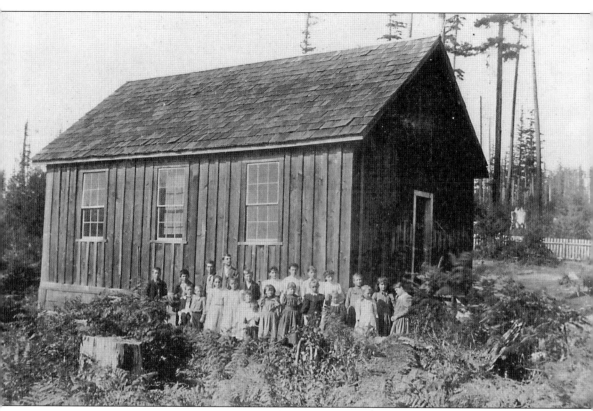

FIRST LIVINGSTON BAY SCHOOL, C. 1900. The county superintendent wrote the following report after her visit to the school in 1895: "This day visited the school in Dist 9. Mr. N. L. Gardner, a graduate of the Ellensburg Normal is the teacher. I was greatly pleased with the working methods of Mr. Gardner. Thirty five pupils were enrolled . . . Most excellent order was maintained without any apparent effort . . . the schoolhouse, though somewhat shabby in appearance on the outside, is very neat and comfortable on the inside. It is well furnished with "patent" desks . . . though a dictionary is lacking. It is the only one of the last three schools visited that is provided with any outbuildings." The original 1884 schoolhouse was later moved to the church land across the road and attached to the church as the social hall. It is still part of the historic church. (Photograph by O. S. Van Olinda.)

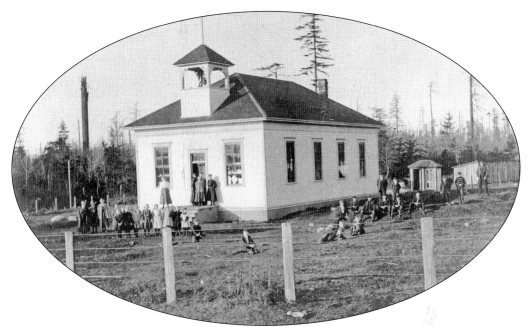

SECOND LIVINGSTON BAY SCHOOL, C. 1910. Both the second and third Livingston Bay schools sat on the top of the hill above Livingston Bay at the intersection of State Route 532 and Rekdal Road. The date of construction of the second school is not exactly known.

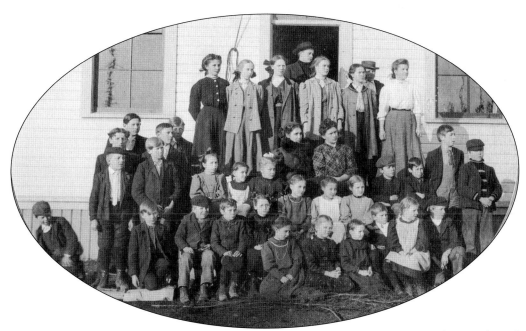

STUDENTS OF SECOND LIVINGSTON BAY SCHOOL, C. 1910. Ada (Frostad) Olson and Pearl (Einarsen) Hansen are among the students pictured in the front of the school on this sunny day. This school burned down in 1913 on a cold December day; no students or teachers were hurt. A third school was built the following year and used until 1937, when schoolchildren on Camano began to attend the Stanwood schools.

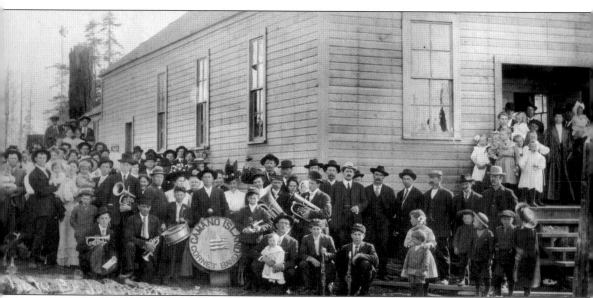

CAMANO ISLAND CORNET BAND AND COMMUNITY HALL. A community hall, built about 1908 by the Camano Island Hall Association, stood on the road between Livingston Bay and Land's Hill. Basket socials, dinners, and music events were popular there. The building was taken down in 1946 or 1947. The lumber was used to build a residence on the same site (south side of State Route 532 and Good Road intersection). The funds raised from the sale of the salvaged materials ($723.45) were turned over to the church.

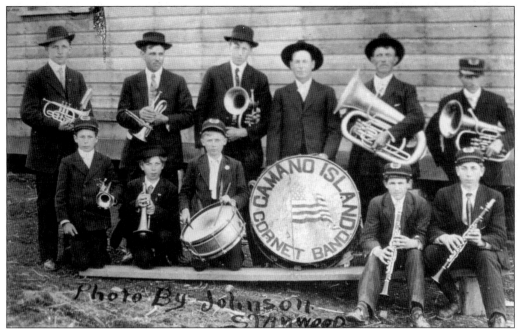

CAMANO ISLAND CORNET BAND, C. 1908. The Camano Island Cornet Band was formed in March 1907 and had its first public appearance in December 1907. Pictured, from left to right, are (first row) Lester Nelson, Arthur Einarson, Harold Knutsen, Oscar Bodin, and Ernest Einarsen; (second row) Sophus Borreson (treasurer), Levi Thompson (secretary), Olaf Knutsen, Carl Land, Pete Wold, and T. W. Magelssen (president). O. N. Dock, who was vice president, is not pictured.

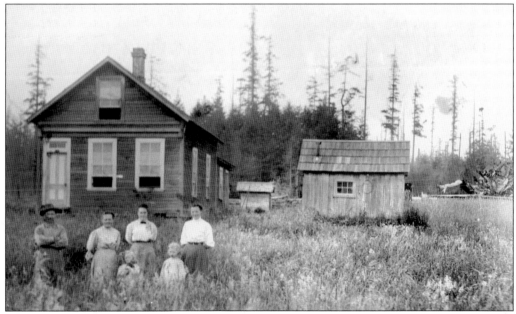

DOCK FAMILY FARM. One of the small "home farms" of Camano was this one owned by Ole N. Dock, Island County commissioner (1920–1924) and Norwegian dairy farmer, and his wife, Tilda. The farm was on the north side of North Camano Drive east of the Pioneer Cemetery and Public Utility District transfer station. Note the giant upended tree root in the background.

TERRY'S CORNER, FORMERLY MCEACHERAN'S CORNER. In this 1999 view, the building on the right is Terry's Corner Fire Station. The intersection of North Camano Drive and Sunrise Drive is known as Terry's Corner for Will Terry, who owned the farm on the hillside on the west side of the road. Before State Route 532 was built, the property, now a park and ride and commercial development, was planted with wheat or hay. Previously the corner was known as McEacheran's Corner, named for the Stanwood doctor who owned it before Terry, around 1912.

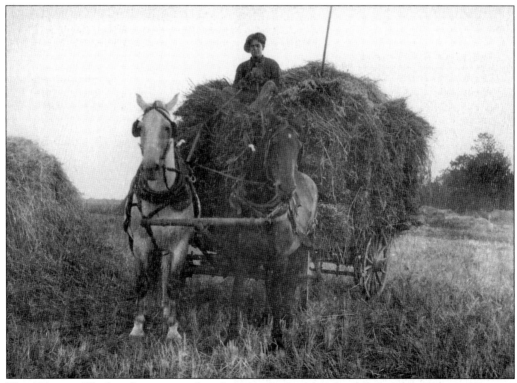

HAY WAGON. The handwriting on this photograph identifies this fellow as Jim O'Brien, who was born about 1894 and lived on his father's farm where Terry's Corner Fire Station is now located. To the south, the area that is now farm fields is part of a vast stretch of bottomland that slopes and drains into Livingston Bay. There was a two-acre cranberry bog along Sunrise Drive that, many years ago, was burned off to be cultivated.

NATIVE AMERICAN FAMILY. John O'Brien of Ireland came to work in the Utsalady Mill and is listed in the 1889 territorial census as a farmer married to a Native American with four children. His children are listed in the school records as early as 1876. In this photograph, Kate Jake O'Brien is surrounded by her children: Ellen, Kate, Mary, Webster, Charlie, Eddie, and James. John O'Brien died in 1908.

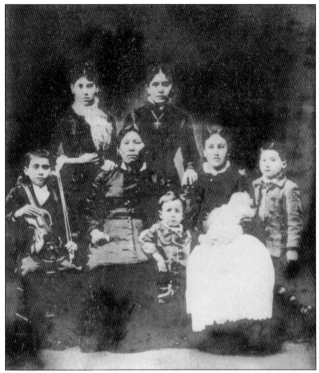

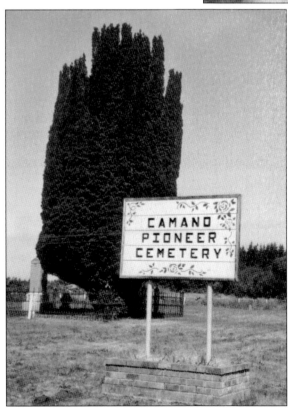

CAMANO PIONEER CEMETERY, 2003. Part of the original O'Brien Farm was sold to Island County in 1892 to become Camano's Pioneer Cemetery.

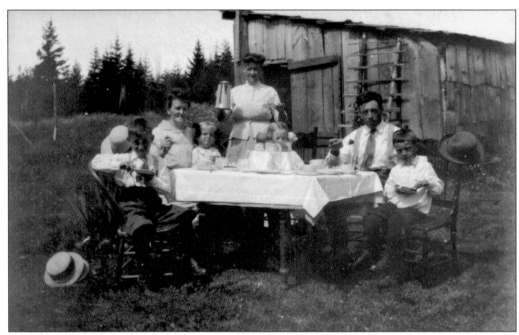

OLE AND JENNE MOE AT CHRISTIANSEN FARM NEAR TRIANGLE COVE. Moe Road, off Sunrise Drive on the east side of Livingston Bay, was named for Ole Moe and his family. This was a happy picnic complete with formal table setting. Unfortunately, the oldest son was killed in an accident while clearing the fields of stumps with dynamite, not an uncommon occurrence.

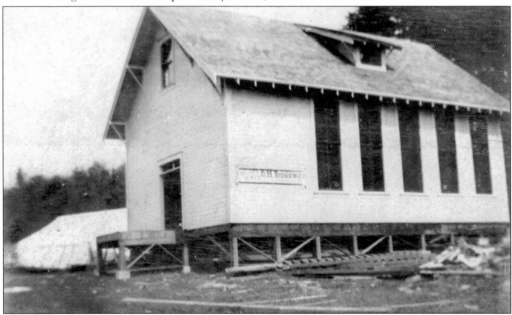

TRIANGLE BAY SCHOOL, DISTRICT NO. 21, C. 1911. District No. 21 was formed southwest of Livingston Bay for those children living around the Triangle Shingle Mill and at Barnum Point. The teacher lived upstairs in the school building. It was located on northeast corner of the bay and later moved to property owned by the Kristofersons, just south of the county offices. It was used as a residence for many years and was recently dismantled by the county for its sheriff's offices.

KRISTOFERSON FARM, C. 1914. The school at Triangle Cove was moved to land owned by the Kristoferson family, whose holdings once included the current ranch, Camaloch, and the Camano Plaza. What remains of the holdings is now the much appreciated pastoral panorama across from the Camano Plaza, purchased in 1912. (Courtesy Pat Kristoferson.)

KRISTOFERSON FARM, 2006. August Kristoferson Sr. purchased his farm on Camano Island as an adjunct to his Seattle dairy business. He never lived to enjoy it, so the family used it as a retreat. It was usually attended by caretakers who managed it as a ranch. Its most recent grazers have been the delightful alpacas. The property has one of Camano's oldest barns and a log cabin said to have been built in 1879. The road was rerouted at some point to travel more directly to the barns.

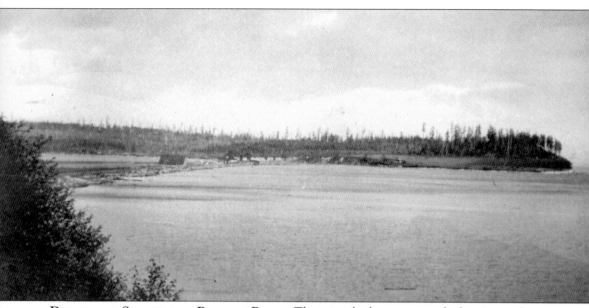

DRIFTWOOD SHORES AND BARNUM POINT. This view looks east toward what is now known as Driftwood Shores (left, with the shingle mill building) and the headland known as Barnum Point on the right. The Barnum family had chickens, cows, pigs, vegetable gardens, and a large orchard. Potatoes and some oats, their cash crops, were picked up by the steamer or scow that brought supplies to the mill across the cove before there was a road. The strawberries on this farm ripened before other farms because of the long afternoon sun. Before building the road with his oxen, Barnum shipped his strawberries (and other crops) by scow. Barnum became Island County commissioner from 1914 to 1915 to promote road building on the island, especially out to his beautiful farm.

Four

EXCURSIONS, PICNICS, AND NEW UTSALADY

It was common for steamboat captains to sponsor Sunday excursions, and Utsalady was a popular destination. Sometimes families would bring groups out to the shore. In July 1901, the *Island County Times* notes that "Utsalady has taken on quite a summer resort air since the arrival of the merry party of campers upon our beach last week. Cycling, driving and surf bathing is the order of the day, while the usual monotony of twilight hours is broken by music and singing which is much appreciated by "we'uns" of Utsalady."

At Utsalady Bay, other farms spread out east of Utsalady Point and a new community began to form at "New" Utsalady. During the time the mill was operating, there were still a few Native American families staying or visiting Utsalady or Brown's Point (Arrowhead Beach). They dug clams, raked smelt, and harvested other seafood and possibly game from this camp. They eventually moved to the Swinomish Reservation or died, as so many did during this time.

It is not clear at what point the school moved from Utsalady Point to New Utsalady, but a November 1901 account in the *Island County Times* describes that the Utsalady Hall was filled to overflowing with a large and appreciative audience for a program of pantomimes to benefit the Utsalady School library. At the close of the entertainment, lunch was served, after which many remained and "beguiled the midnight hours by tripping the light fantastic toe."

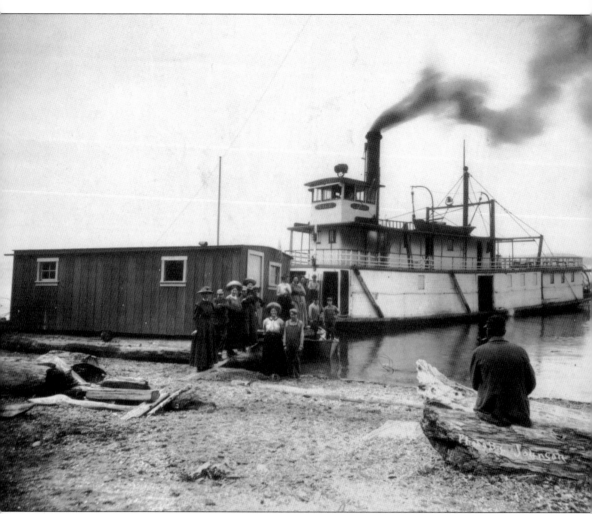

Stern-Wheeler Lily and Passengers. The shallow drafts of the large steamboats could let people off at any reasonably deep shoreline, and Camano Island was one of those sites. The *Lily* was a familiar local steamboat that transported goods and passengers between Stanwood and Seattle in the early 1900s and would stop at places in between if signaled. In 1905, this *Stanwood Tidings* account stated, "A large and merry party of Stanwoodites chartered the steamer *Lily* and left Monday noon for Rocky Point where they expect to remain in camp for ten days or two weeks. Tidings is informed that there now are thirty eight tents in 'Camp C D' as it has been named, with a population of about 150. Those who went on the *Lily* were Mr. and Mrs. George Ketchum and children, Mr. and Mrs. C. R. Durgan and sons, Mr. and Mrs. C. W. Chadbourne and son, Mr. and Mrs. T. J. Butler, Mrs. G. M. Mitchell, Miss Valentine, Ellen and Christine Olson, Edna Conners, Laura Anderson and Meta Moran."

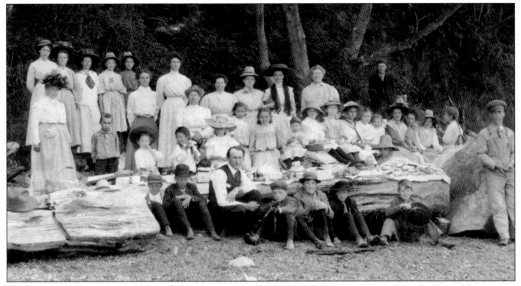

PICNICS. This picnic is said to be at Rocky Point around the corner from Utsalady and has some young Stanwood residents in the group, including Clyde Brokaw, Chris Simonson, Alf Willard, Harold and Fred Ketchum, and Anna Gilchrist. Clyde Brokaw was a banker in Stanwood who bought property at Rocky Point. Brokaw Road is named after him.

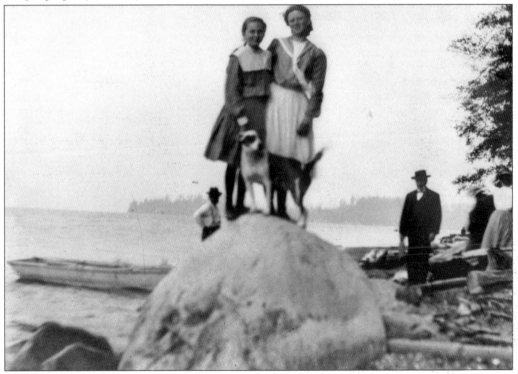

LANDMARK ROCK AT UTSALADY. Part of a series of photographs, this picture shows two young girls and their dog posed on a rock that is still a beach landmark near the Utsalady boat launch. Brown's Point is in the background. Carl Ryan is responsible for capturing the following series of photographs documenting this day at the beach.

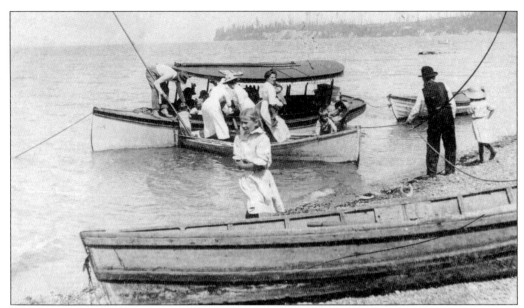

S. A. Thompson's Company Launch at Utsalady, c. 1914. S. A. Thompson was a general store owner in Stanwood from 1895 until about 1937, when he died. His partners, brothers Alfred and Carl Ryan, are along on this outing and have apparently brought their families for a picnic at Utsalady. Note Brown's Point in the distance. Carl Ryan's young niece, Olga Ryan, is in the foreground.

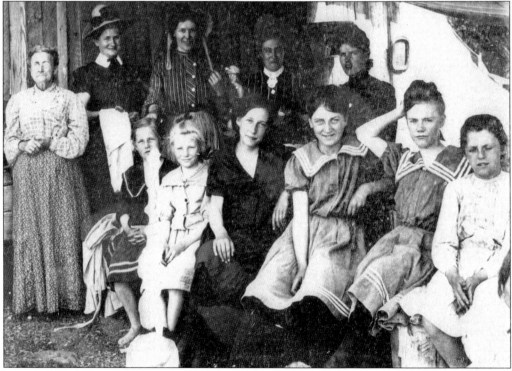

Bathing Beauties at Utsalady. In the shade of one of the shacks are these young girls, part of the Thompson-Ryan picnic.

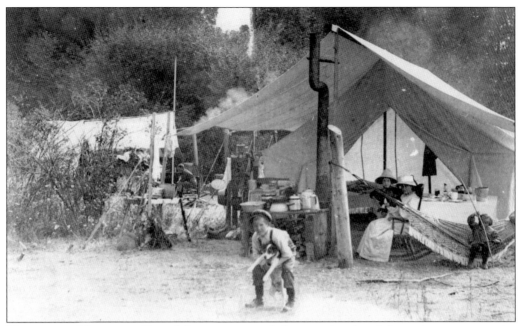

TENTING AT UTSALADY. Part of the same series of photographs, this elaborate camp seems quite comfortable—complete with a cookstove.

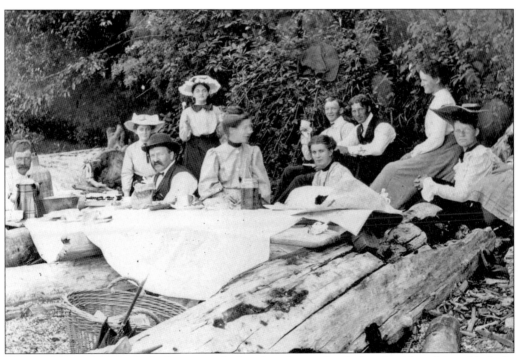

PICNIC IN DRIFTWOOD. A shady spot on the beach is the site for the lunch with a white tablecloth. S. A. Thompson is in the center looking at the camera, surrounded by the Ryan families of Stanwood. The wonderful hats and ties lend a sense of formality.

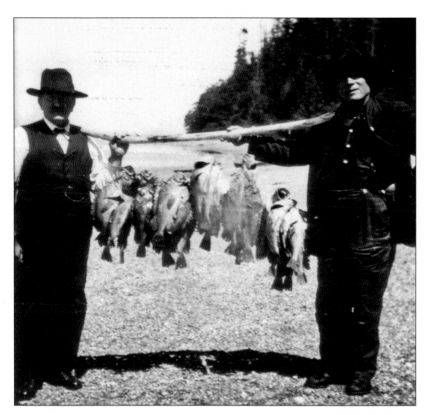

FISH CATCH. S. A. Thompson and a friend are pictured here with their fish catch of rock cod and sea bass.

TOWELS AND TENTS. These three unidentified ladies are enjoying tea and a picnic in the sun.

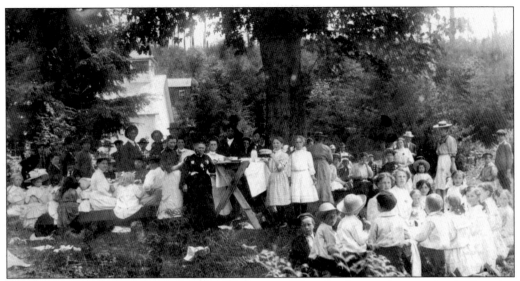

WHITE DRESSES AND CAKE ON SCHOOL GROUNDS. The school grounds were also the location of many gatherings and picnics at New Utsalady. The occasion is not known, but it seems to be a rather sunny, warm day—even in the shade of the large tree in front of the Utsalady School.

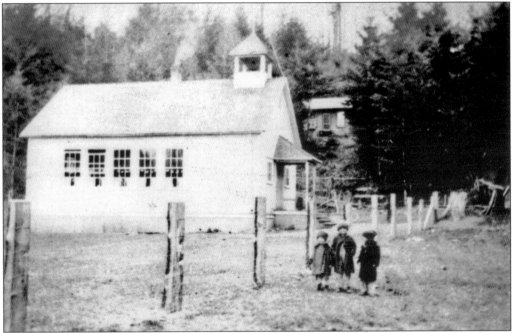

THE "NEW" UTSALADY SCHOOL, C. 1924. The three little girls pictured are thought to be Pearl Mellum and the Tew sisters. School was taught at Utsalady Point near the mill through the 1890s, and at some point it moved to "New" Utsalady. This schoolhouse is now a private residence. The year before the Utsalady Mill closed, Albert Ekle purchased and platted "New Utsalady." Though he never lived here, he deeded land for the new school. In 1926, his son brought his family from Minnesota.

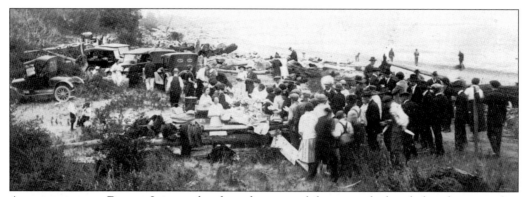

AUTOMOBILES ON BEACH. It is not clear how the automobiles got to the beach, but this is another picnic thought to be at Utsalady. Local photographer John T. Wagness captured this image but did not leave much information about the occasion.

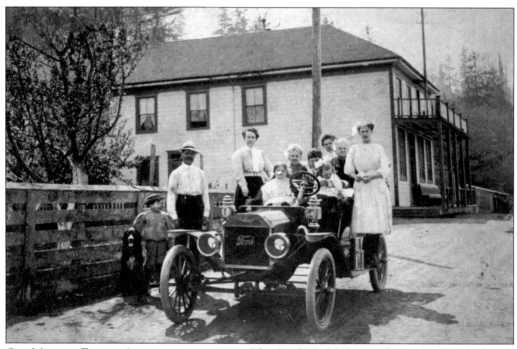

OLE MELLUM FAMILY AUTOMOBILE, C. 1910. This Ford Model T is on the road along the beach at Utsalady in front of Mellum's hotel. Ole Mellum returned from the Klondike gold rush and found his way to Camano Island. He operated a logging camp, was a fisherman, and a jitney driver for the Auto Stage Line between Utsalady and Stanwood.

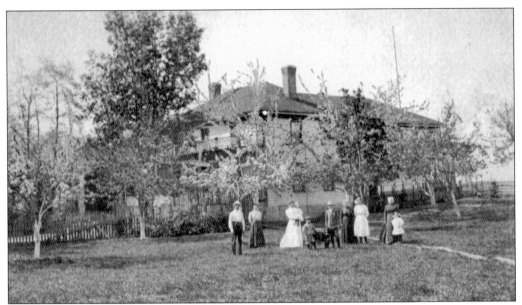

NEW UTSALADY HOME AND HOTEL, C. 1910. The Mellum family built this hotel with a saloon downstairs; the family lived upstairs. This home was on the New Utsalady shoreline and the road ran between the house and the shoreline west to Utsalady Point. The road was bypassed above several years later.

UTSALADY LADIES AID BUILDING, C. 1949. The Utsalady Lutheran Ladies Aid was established in 1908 at the home of Mrs. H. P. (Constance) Olsen who was the first president. They formed their group, with the assistance of Pastor George Larson, to provide support for religious training for the children of the community. Pastor Christenson of Our Saviour's Lutheran Church in Stanwood drove a horse and buggy out to Utsalady twice a month to provide religious services. The building was built in 1924 by Jack Brown with lumber from his mill.

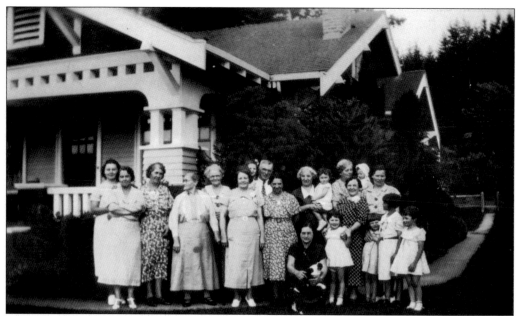

UTSALADY LADIES AID MEMBERS AT LAURA BROWN'S HOUSE, 1937. The 7 charter members grew to 14 in 1914 and, by 1915, Ekle deeded a lot for the Ladies Aid building, which they began planning. Ekle required that the ladies would allow no card playing, gambling, or drinking in the building or on the grounds. (Courtesy Donna Shroyer.)

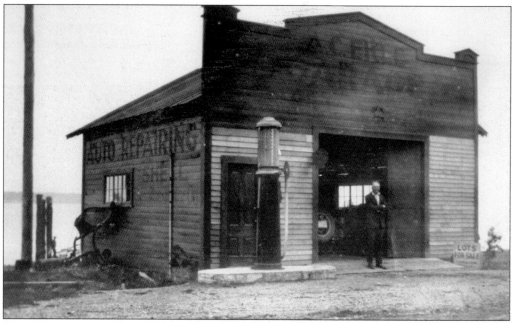

EKLE GARAGE AND GAS STATION, C. 1926. The Ekle Garage and gas station was located at Tract C Beach access on the waterfront along Utsalady Road and across from the Ladies Aid Hall. The station provided repair and fuel for boats that were in Utsalady Bay, as well as cars and trucks traveling across the road. Al Ekle Sr. is standing in front of his station near the sign "Lots for Sale." (Courtesy Marian Larson Turner.)

TWIN CITY NEWS ADVERTISEMENT FOR THE ECKLE [SIC] GARAGE, 1937. In the mid-1930s, the station was moved to the corner of Essex Street and North Camano Drive. Betty Rolfson Bietz Bonjorni and Marcella White Zelk had a thrilling ride hiding in the station when it was moved from the waterfront property. Ekle is the correct spelling and is the name of one of the roads in the neighborhood.

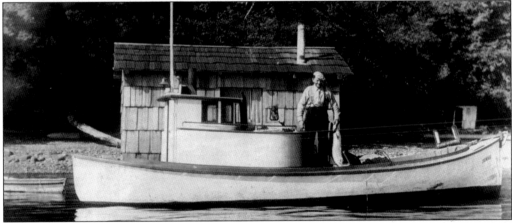

FISHING BOATS AT UTSALADY. There were 6 to 10 small one-man commercial boats at Utsalady in the 1920s and 1930s. Harold Strand moved to New Utsalady in 1930 and started fishing with his 28-foot gillnetter, the *Black Mariah*. He fished for crab and salmon and sold his catch to the fish buyer in LaConner. Here he is holding a prize 75-pound salmon he caught around 1932. Each year on the Fourth of July in a fire pit on the beach, Hattie Strand baked salmon, wrapped in seaweed, for everyone.

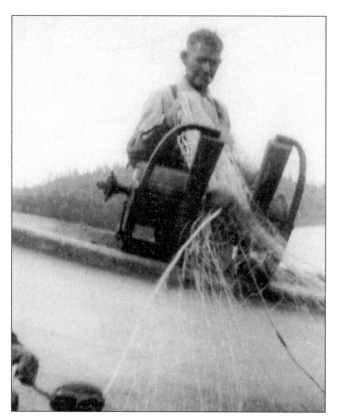

HAROLD STRAND AT BOW PICKER, HAULING IN NET. Fishermen usually went out once a day into Utsalady Bay. They checked the nets more often when seals were around because they would eat the bellies of the fish and leave the rest. When the killer whales were around, there were no fish to be found.

UTSALADY REAL ESTATE ADVERTISEMENT, STANWOOD NEWS, JULY 14, 1938. The Puget Mill Company, one of the largest landholders on Camano, held on to its property for quite a few years after logging it.

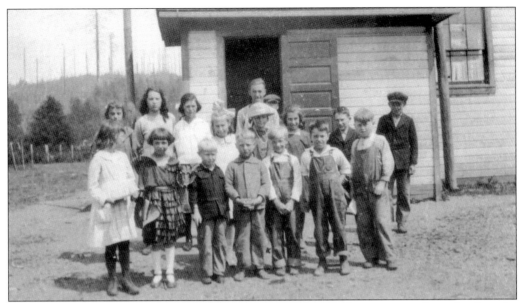

ROCKY POINT SCHOOL. Official records do not show it, but there was another school in the Utsalady District No. 5 at Rocky Point. It started about 1914 and held classes until 1927. Pictured here are some of the students in front of the school, located east of the intersection of Sunset Drive and West Camano Drive.

ROCKY POINT SCHOOL BUS. The school district could not afford a real school bus at the time so Charlie Brown (logger and operator of the Maple Grove Resort) and his brother M. T. "Jack" Brown (shingle mill owner and county commissioner) went to Seattle and bought an old delivery van with canvas sides. They built benches on each side for the kids to sit on. The bus picked up the children in the Rocky Point area and one little boy who came over on the ferry from Whidbey in the morning and took them into Stanwood to high school.

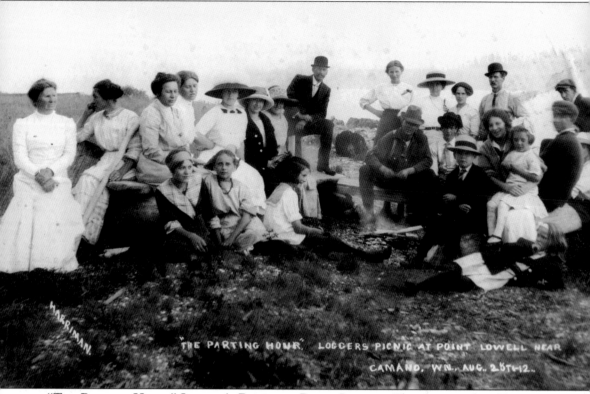

"THE PARTING HOUR," LOGGER'S PICNIC AT POINT LOWELL. The photographer, Harriman, took this picture of a picnic at what is now Camano Island State Park in Saratoga Passage on August 25, 1912. The names of the people in the photograph are lost. Point Lowell was named by Wilkes in the U.S. Exploring Expedition of 1841 when they sailed through the Puget Sound. James Lowell was "captain of the forecastle" of one of Wilkes's ships.

Five

CAMANO CITY STUMPS AND STEAMERS

On the western shoreline of Camano Island, the body of water called Saratoga Passage extends from Port Gardner Bay northwest to Skagit Bay with Whidbey Island on the opposite shore. In the early days, water transportation still linked the islands even though a bridge from Stanwood was built in 1909 over the river. It would still take a several years for roads to reach the western and southern parts of the island.

Around 1898, the Esary brothers—James, Andrew, and Tom—began logging the area surrounding the spit known to the Native People as O-ow'alus. The fresh water available there would make it a natural camp for Native Americans and for new commercial ventures. This area became known as Camano City for a time.

The Esarys and their associates, among them several members of the Garrison family, logged at Madrona, Elger Bay, Cama Beach, and Utsalady. Theirs was one of the largest of about 10 to 20 camps that moved around logging sections at a time. They operated a lumber mill intermittently from around 1907 until around 1927. For about two years, from 1908 to 1910, the Camano Commercial Company (also owned by the Esarys and their associates) operated a logging railroad that climbed into the woods on the north side of the Chapman Creek canyon. In 1907, Camano City had a small one-sheet newspaper called the *Camano Enterprise*, operated by N. C. Garrison. According to the newspaper, there was a wharf, blacksmith shop, two hotels, school, general store, confectionery store, and a boatyard at this location. A waterworks supplied water from springs. The mill provided electricity for the community.

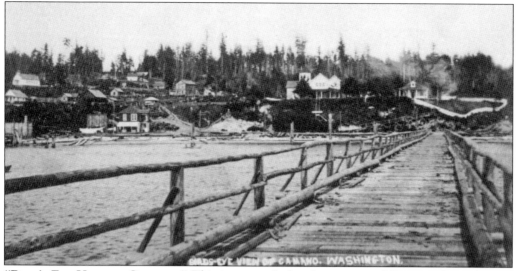

"**BIRD'S-EYE VIEW OF CAMANO.**" This is more of a boat's-eye view of Camano City, pictured around 1912. This area is just south of the intersection of the current Chapman Road and West Camano Drive. The mill buildings would have been on the left (north), just out of view. The school is on the upper left. Hotel Camano with its distinctive turret is prominent.

HOTEL CAMANO, 1908 AD. The hotel with its turret was there in 1907 and part of it has been said to have been hauled in on a scow and towed up the hill. Loggers and real estate clients were the primary guests. Old newspapers indicate it was one of two hotels in Camano City at the time.

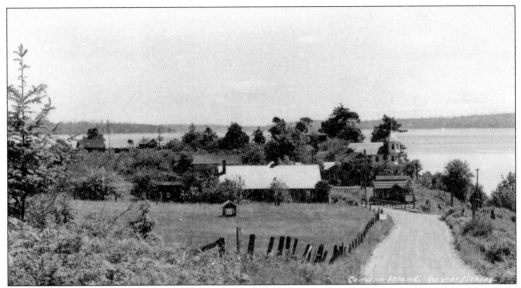

ALL-YEAR FISHING, C. 1940S. This scenic view of Saratoga Passage (in the distance) shows the unpaved West Camano Drive looking south toward Hotel Camano. The sign across the top of the small real estate building at the fork in the road says "Waterfront Tracts." The road goes off to the right and down to the beach where the sign directs visitors to the Camano Beach Resort. The small roadside sign on the left points to Cama Beach Resort.

CAMANO CITY, 2006. This same view as the image above shows the section of the landmark former Hotel Camano that still exists as a small inn without its turret. In the 1920s, Mrs. Rennsalaer took over the hotel and provided campgrounds, a community kitchen, outing supplies, and boats. For a few years, it was known as the El Camano Lodge and was popular for its chicken dinners. In 1953, it was sold to the Brouillet family who operated it as a restaurant. A later advertisement lists Mr. and Mrs. Ray Fishburn as managers of the lodge. Before becoming an inn again, it was a nursing home.

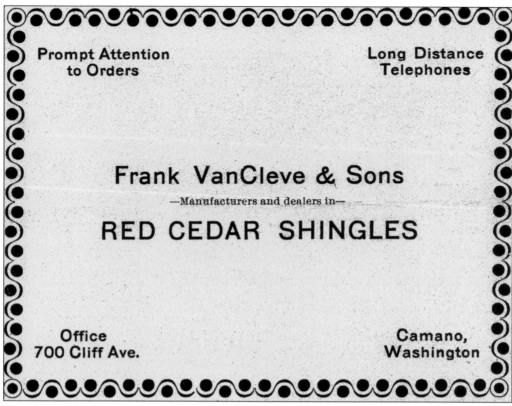

RED CEDAR SHINGLES, CLIFF AVENUE. The Van Cleve shingle mill was started at Camano City in around 1904. There was an abundant amount of Western red cedar for the shingle mills of the day. When the mill was first built, waterpower was used, but it did not work well so a steam engine was installed. It had two upright shingle machines and employed six or seven men. It burned in 1910.

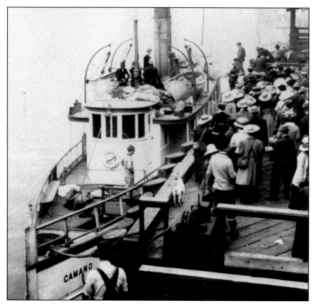

CAMANO. The propeller steamer, the *Camano*, was built for the Island Transportation Company in 1906 to replace the *Fairhaven*, which served Whidbey and Camano Islands between its run from LaConner to Seattle. The *Camano* ran until 1912 when it was rammed and sunk in Everett. A steamer, the *Calista*, met a similar fate, also rammed and sunk in 1922 while carrying passengers from Mabana and Camano City. All were rescued and survived.

Island Transportation Co.

Str. ,'Whidby" Time Card:

LEAVING

NORTH BOUND	SOUTH BOUND
Seattle........4 P. M.	LaConner (Subject to
(Except Sat. and Sun.	tide)
Sun. 3 p. m. touching	Utsaladdy...6;30 A. M.
Everett.)	Oak Harbor 7:15 "
Clinton......6:15 P. M.	San de Fuca 7:45 "
Langley..... 6:45 "	Coupeville 8:30 "
Saratoga.....7:05 "	Camano.... 9:15 "
Camano......7:45 "	Saratoga....9:45 "
Coupevllle...8:30 "	Langley....10:10 "
Oak Harbor...9:15 "	Clinton....10:35 "
	Arriv'g Seattle 1 P. M.

Str. "Camano" Time Card

(Daily except Sunday.)
LEAVING SOUTH BOUND

Coupeville............7:00 A. M.	
Oak Harbor......................7:30 "	
Camano 8:15 "	
Langley:.. 9:15 "	
Clinton 9:45 "	
Arriving at Everett...... 10:I5 "	

Leaving Everett for Coupeville, 3 P. M.

Brown's Point, San de Fuca and Saratoga, subject to call.

STEAMER SCHEDULES, 1906–1912. The *Whidby* (an alternate spelling at the time) served Camano Island on its run between Whidbey and Seattle for four years. In 1911, it caught fire, and its remains are still found off Maylor's Point in Saratoga Passage off Whidbey Island. The *Camano* was rebuilt and renamed the *Tolo* but again sunk, this time carrying 53 passengers. Four of them died. Gradually private ferries took over main routes until 1951, when the State of Washington took over the Black Ball Line.

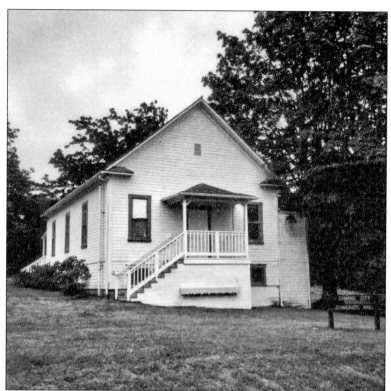

CAMANO CITY SCHOOL, C. 2000. District No. 18 officially formed in 1903. When the school was actually built is not known, though it was probably about 1906. According to school records, the land was deeded to the school district in 1911 from the Camano Land and Lumber Company for $1. Now this building is used by the fire department as a community hall.

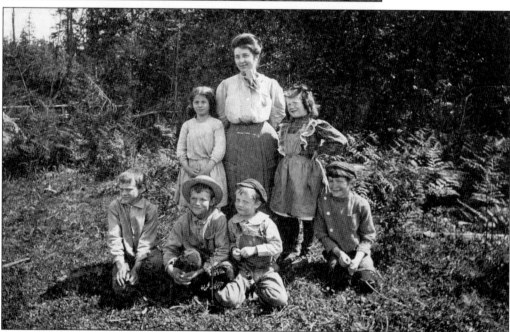

TEACHER MAUDE HAYDEN, MAY 1905. Miss Hayden stayed with the family of Jim Esary while teaching at Camano City School. She received her teaching degree in Iowa in 1900 and came to Washington. She told her children that the scariest part of the trip was the boat ride to Camano because she had never seen so much water in her life. (Courtesy Janet Huntley.)

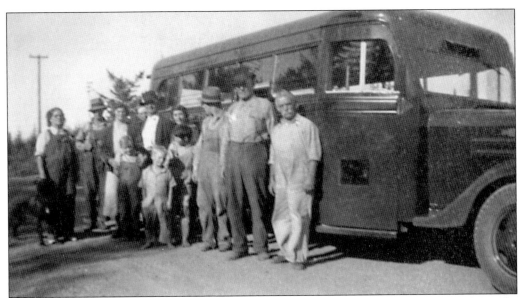

CAMANO SCHOOL DISTRICT NO. 18 SCHOOL BUS, C. 1935. In 1928, Mr. Hopkins drove the bus for Camano City School. The driver for the Mabana, Algers Bay, and Triangle Cove high-school students was Mr. Harnden. Before this beautiful new truck, students found many ways to school, and sometimes the high-school boys drove the buses themselves. Herman Moa, the bus driver for a few years, would pick up the kids and drop them off at school, then pick up milk from the farmers and deliver it to Arlington. When he finished his delivery, he would go back to the school to pick up the students and take them home.

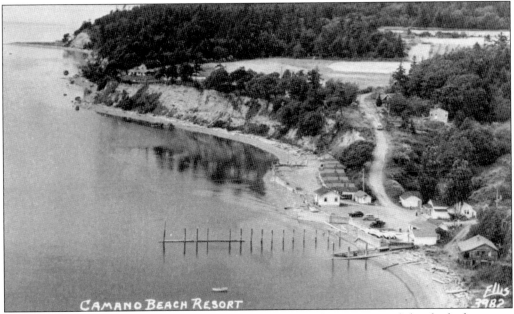

CAMANO BEACH RESORT, C. 1940. These pilings are the remains of the dock that once served the mills and carried passengers. In this view are the resort cabins, old store, and boat-rental buildings at Camano City.

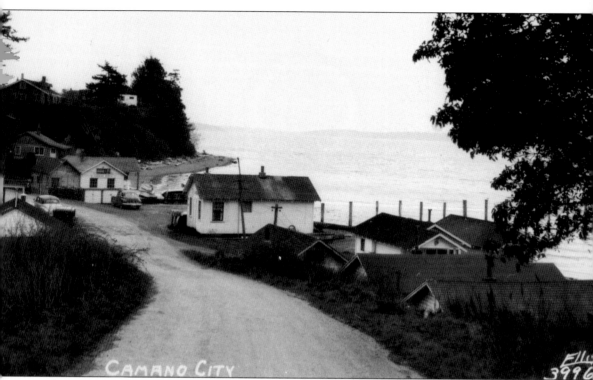

CAMANO CITY, C. 1940. After the Camano Commercial Company dissolved in 1927, the dreams for Camano City as a "town" were long past. The small year-round stream, Chapman Creek, runs under the road here and down from the gully to the east. Resort cabins are on the far right. The car is parked in front of the boat-rental buildings and piling remains of the old wharf or perhaps other early structures. On the bluff at left is the historic Cama Home, owned by the Stradley and Risk families (until recently), who established and operated the Cama Beach Resort.

Six

MABANA AND THE SOUTH END

Activity on the south end did not really start until about 1911, when Nils Anderson began logging operations and built a 900-foot wharf at a place he platted as Mabana. About that same time, Mr. E. G. "Jack" Hogle started a small store and post office. In 1916, perhaps as a result of Anderson's influence as a county commissioner, a wagon road was put in as far as Mabana.

Few photographs exist of the earliest years, but it is worth noting that the community had enough loggers' wives to form its own Ladies Aid. They held their first bazaar in the "new schoolhouse" on December 15, 1916. In 1919, though many of the members were very poor themselves, they sent $5 from their fund-raising efforts to benefit Red Cross Armenian and Syrian infant relief. Roads were slow to improve, but people found work where they could and tried to hang on to their homesteads. Once logged, the land was very inexpensive and not very good garden soil. Families raised chickens and owned cows. As in other rural areas, Prohibition created an illegal market for a little moonshine to be sold in town or to visitors from Seattle. The south end of Camano has a bit of a reputation as a rather rough place because it was just the kind of isolated place where locals might have worked as middlemen for the rumrunners from Canada. However, those legends are mostly lost in family histories and not just on the south end, unless Cavalero Beach and Rocky Point can be called the south end.

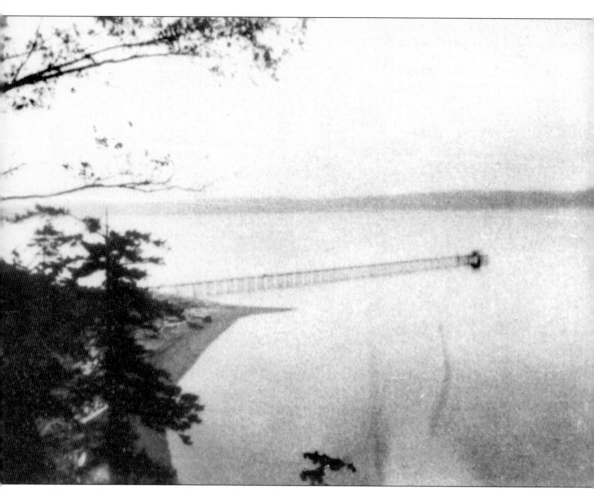

MABANA SHORELINE AND DOCK. The small natural barrier beach had enough space for buildings, and the hotel, store, and post office were said to be on the beach. In 1926, Nils Anderson sold 66 feet of shoreline to the Port of Mabana for $500 for public access. At the time, it included the dock. According to Port of Mabana minutes, repairs were still being made to the dock funded through residents' subscriptions in 1934. In 1935, the commission levied a tax for maintenance. Maintenance continued until 1942, when the port commissioners voted to discontinue the dock maintenance and the county took over the road to the beach. Though the quality of this photograph is poor, it shows the extent of the dock that connected the south end of Camano with the world.

MABANA DOCK. The beach along the western shoreline of South Camano is sandy, shallow, and slopes gradually to deeper waters. Before the dock was built, rowboats would hail the launches or steamers and row out to meet them. The dock had to be 900 feet long so even shallow draft steamers could tie up. The *Ruby Marie*, a launch, was the first boat that served Mabana. The *Alvarene* took its place when the dock was built.

MABANA RESIDENTS ON DOCK. These Mabana children seem to be interested in the waters below the dock. The dock had a narrow-gauge track for a small railcar, used to move materials between the shore and the steamers at the end of the pier. Today, in the spring, residents observe the gray whales that feed on the sand shrimp near the sandy beaches on their way back to Alaskan waters from California.

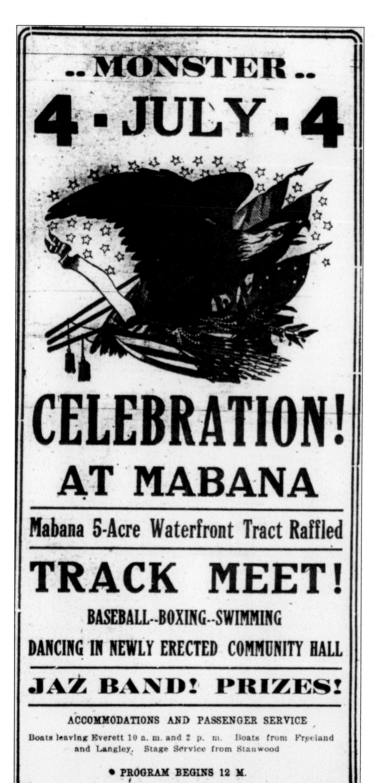

.. MONSTER ..
4 · JULY · 4
CELEBRATION!
AT MABANA

Mabana 5-Acre Waterfront Tract Raffled

TRACK MEET!

BASEBALL--BOXING--SWIMMING

DANCING IN NEWLY ERECTED COMMUNITY HALL

JAZ BAND! PRIZES!

ACCOMMODATIONS AND PASSENGER SERVICE

Boats leaving Everett 10 a. m. and 2 p. m. Boats from Freeland and Langley. Stage Service from Stanwood

● PROGRAM BEGINS 12 M.

FOURTH OF JULY, 1919.
In 1912, Anderson platted Mabana and began to sell lots along the shoreline for summer cabins. These tracts are now part of the few remaining majestic stands of second growth fir along the south end shoreline that resemble what the tall trees must have once been like. To promote the sale of his logged-off properties and the beginnings of a small community at Mabana, Nils Anderson sponsored the celebration here. Anderson also was instrumental in forming the Mabana School District No. 23 in 1910. For the first few years, classes were held in a small building that he owned near the bluff (tract No. 1). In 1916, classes moved to Anderson Hall, the schoolhouse that is now a residence across from the current Mabana Fire Station.

MABANA SCHOOL, 1916. The building of a school in that day was a local project. That year, a newspaper announcement read, "The ladies of School District No. 23 will give a picnic dinner on the new school site at Mabana June 10 (1916). The gentlemen are invited to come and bring axes and other implements of war to engage in "le Travail" of clearing space for the school grounds. Dancing will be the entertainment of the evening. All are requested to come and join in the good work."

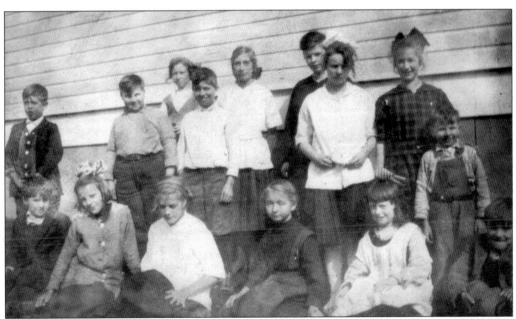

MABANA STUDENTS, 1920. Beatrice Harth was the teacher at Mabana School in 1919–1920. There were 10 girls and 14 boys enrolled in the Mabana School that year—Frieda, Georgia, and Anna Auvile, Waive Brooks, Geraldine Finn, Grace Ingham, Pearl Reed, Borghild Schaffer, Marion Wilson, Jennie Woodard, Frank and Oakel Auvile, Allen and Howard Eggers, Engene Ingham, Alonza Matsen, Merle and Roy Proper, Willie, Byron, and John Teeple, Sidney and Burnam Johnson, and James Brooks.

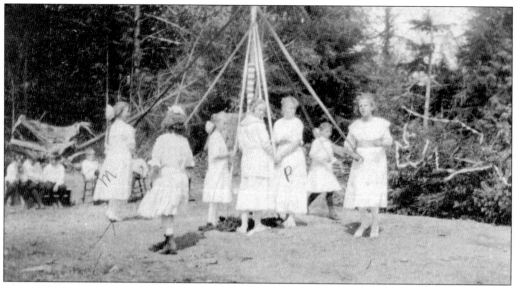

MAYPOLE DANCE, 1918. The maypole dance was a rite of spring. Teacher Pearl Anderson Wanamaker is pictured in the center. She was the teacher for two years before moving to Montana, returning a year later as the county school superintendent. She went on to become one of Washington State's most influential superintendents of schools and legislators.

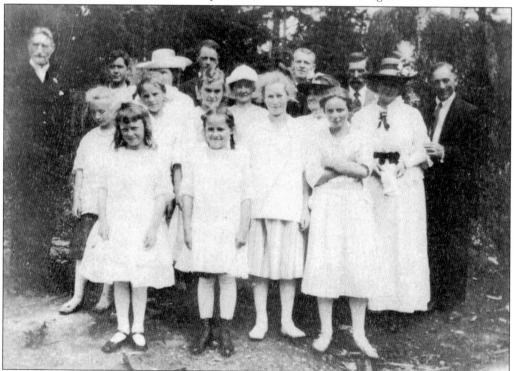

MABANA SUNDAY SCHOOL, 1917–1918. One of the most important organizations of this small community was the Sunday school, started around 1912. In 1916, they held Easter services in the Mabana Hotel lobby. This group continued as part of the American Sunday School Union. It now has its own church, known as the Mabana Chapel.

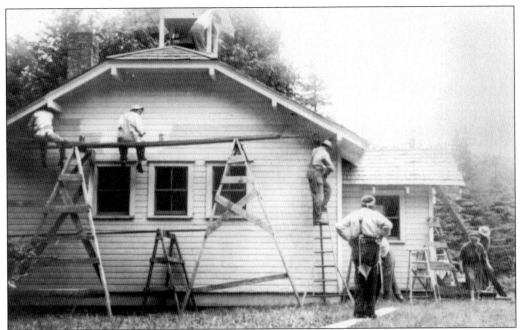

PAINTING MABANA SCHOOLHOUSE. The Mabana schoolhouse has long been recognized as a historic place on Camano, and here it is being cared for as part of the South Camano Grange contest activities. The building was used as the Mabana Sunday School before it was donated to the Mabana Ladies Aid in 1962. It was sold in 1983 and remodeled as a residence, with much of its original architectural characteristics intact.

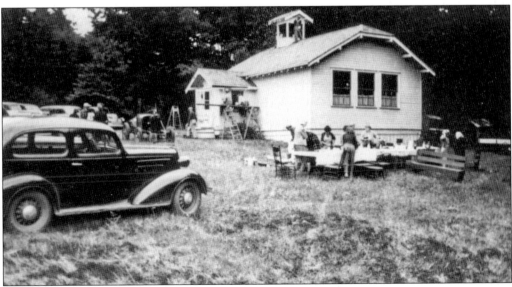

LUNCH FOR VOLUNTEERS. As part of the 1949 National Grange Community Service contest, Grange and neighborhood volunteers sandpapered and painted the rusty school bell; rebuilt, reroofed, and repainted the toilets; arranged rocks around the flower beds; and painted the school building. As part of the fun, a picnic was provided for all the volunteers.

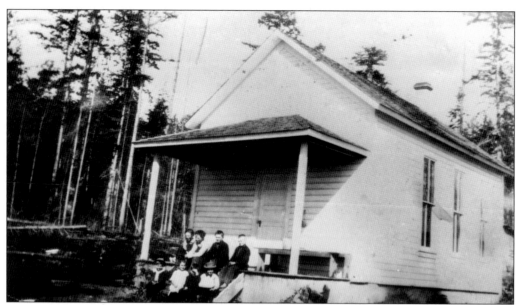

ALGER'S BAY SCHOOL, C. 1920. About four miles north of Mabana was Alger Bay, now called Elger Bay. The students of Alger Bay were from the Fitch and Harnden families (and a few others), who lived in that area. It was part of Island County District No. 23 with the Mabana School. The building still exists as a residence across from the South Camano Grange. Dennis Harnden came to Camano Island to work in the logging camps and later brought his family by barge to Elger Bay.

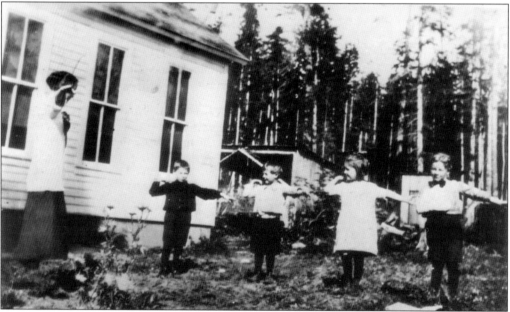

EXERCISE HOUR AT ALGER'S BAY SCHOOL. At Elger Bay, there was a shingle mill that undoubtedly bought logs and bolts from surrounding shorelines until about 1910. Early school records list the name of the area as Alger's Bay, but how it got its name is a mystery. However, a Martha J. Alger purchased property in the vicinity in 1872 and 1873. County records list the local shingle mill as the Elger Bay Shingle Company.

Seven

Auto Camps, Cabins, and Fishing Resorts

By the 1920s, automobiles had become the major mode of transportation, enabling families to travel on their own for vacations. In a single generation, people changed their long-distance travel habits from the waterways and railroads to automobiles. Communities no longer began at the confluence of rivers; commercial centers were now built up at the intersections of highways. Camano Island provided wonderful beaches for picnics, often at the same places of early Native American villages—usually a level place to build a shelter with a water source. In the 1920s, people came in automobiles, enduring the muddy or dusty former logging roads to camp out, rent a boat, and enjoy the protected coves and panoramic views of the mountain ranges and waters.

Local entrepreneurs were ready to take advantage of the shoreline property that could be sold and the opportunity to provide cabins and boats for rent to workers who had vacation time to fish and celebrate time away from the city and work. Between 1920 and 1960, about 20 resorts were established, often changing owners many times, providing fishing boats and cabins for vacation rental. The resorts hosted the popular salmon fishing derbies starting in 1940, scout group activities, picnics, and festivals to attract tourists. They also began to buy lots for their own small cabins. Many families would spend the whole summer on Camano; father would drive back to the city to work during the week and mom and the kids would stay to enjoy the beaches and outdoors, usually in quite primitive conditions. The resorts were family operated with occasional hired help during busy times or for specific jobs.

HAPPINESS
Beckons to
Camano Island
No Ferry--Steel Bridge
Easily Accessible Through Stanwood Good Roads

Your week-end or your entire summer spent on Camano Island will be a long remembered vacation—you will find beautiful scenery, numerous camps and cabins for your comfort.

HAPPINESS BECKONS, JULY 3, 1930. This *Twin City News* advertisement from the beginning of the Depression accompanied an article describing 15 places on Camano Island to rent boats and cabins. Utsaladdy, Madrona Beach, Camano Beach, Camp Grande, Onamac Park, Camp Pleasant, and Camp Comfort were all on the west side. Real estate agent Inez H. Miller rented "electric lighted cabins," and she could be found at the Lunch Box at New Utsalady. Also at New Utsalady was Rolfson's Boat House, which had a dock.

Camp Far Away

ONE OF THE FINEST AND CLEANEST CAMPING PLACES ON COAST

Artistic Cabins

Boats — Camping — Sandy Beach

Mabana Road—Address: Mabana

F. E. SWANSON, Owner

Pebble Beach
KNOWN AS COX'S SPIT

Boats — Cabins — Fishing — Bathing

Road to water—community kitchen right on beach

Mr. and Mrs. W. F. Fortson own and operate Pebble Beach, located on down the Island from Mabana, on a new and good road.

CAMP FARAWAY AND PEBBLE BEACH. A newspaper article in the *Twin City News* in 1930 featured four camps on the south end of the island—Camp Sea View, operated by Mr. and Mrs. R. B. Evans; Camp Faraway; Camp Olequa (an Indian name meaning "beautiful scenery"), operated by the Petersons, included cabins and spacious campgrounds; Pebble Beach (formerly Cox's Spit); and Mabana with a "store, gas, cabins, boats and good water."

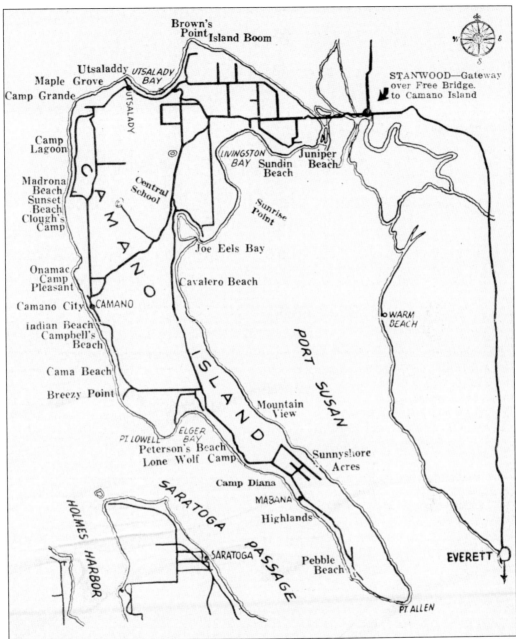

MAP FROM BROCHURE BY STANWOOD COMMERCIAL CLUB. Several versions of this *c.* 1944 map appeared in the 1940s and 1950s, but they were rarely dated. Later versions were produced by the Camano Commercial Club, which began around 1948, and the East Stanwood Commercial Club. Each map has a slightly differently list of resorts and place names. Those that were known to exist (although they are not listed here and there is almost no information available on them) are Camp Diana, Rockaway Beach, Lone Wolf Camp, and Tyee Beach. Of these, Tyee Beach (now a much larger beachfront community on Port Susan) had seven cabins and rental boats beginning in 1944. It operated until the early 1960s. It was the only "resort" on the Port Susan side of Camano Island.

SALMON DERBY CAMANO ISLAND

(Via Stanwood Bridge—No ferry)

Qualify Now till May 31 with salmon 5 lbs. or over

Finals — June 6

$1,500 in Prizes

More Salmon per Boat
the Year Around

QUALIFY AT RESORT SPONSORS

Reids	Indian Beach
Camano Beach	Sunset Beach
Madrona	Camp Lagoon
Camp Grande	Maple Grove

SALMON DERBY, PACIFIC NORTHWEST SPORTSMAN ADVERTISEMENT, APRIL 1948. In 1940, the Camano Island Resort owners sponsored a 26-week Salmon Derby from May until October. Prizes were offered for the three largest fish caught each week. Stanwood and East Stanwood merchants helped by providing prizes for those who rented boats from the local resorts. A $50 monthly purse was offered for those fishing from their own boats. The largest fish caught that year was 36 pounds, 6 ounces. One hundred thirty fish were caught at a total of 1,664 pounds.

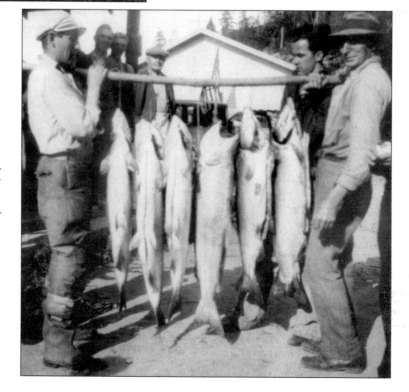

FISHERMAN'S PARADISE, C. 1945. This catch was a total of 208 pounds. The largest king salmon caught was 52 pounds. Charlie Brown, owner of Maple Grove Resort, is on the right. Other participating resorts that year were Utsaladdy, Camp Lagoon, Madrona Beach, Clough's Resort, Camano City, Indian Beach, Campbell's Camp, Cama Beach, Onamac Park, and Sunset Beach.

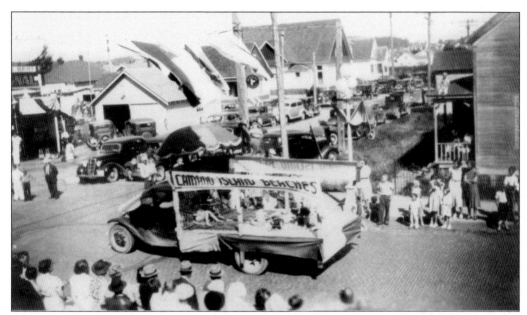

CAMANO ISLAND BEACHES. To promote the resorts and businesses on Camano Island, Island County commissioner M. T. (Jack) Brown built this float for the Harvest Festival parade in Stanwood during the 1940s. This view of 102nd Avenue NW in Stanwood looks northwest.

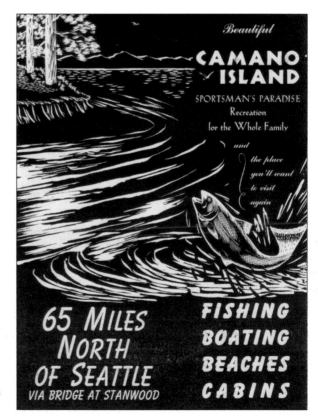

BEAUTIFUL CAMANO ISLAND. This was one of the more elaborate brochures produced, probably in the late 1950s. The seven resorts listed included Cama Beach, Camano Beach Resort, the Camano Lodge, Camp Lagoon, Camp Grande, Indian Beach Resort, and Maple Grove.

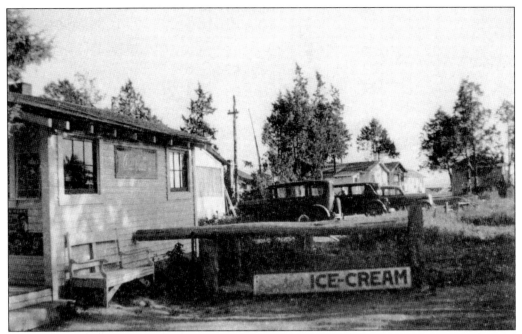

ONE OF TWO JUNIPER BEACH STORES, C. 1938. One of the first auto camps was at Juniper Beach. Later there were two small stores at the beach—Hawley's and the Juniper Beach Store, operated by the Maris family. Several picnics were sponsored at Juniper Beach in 1922, sponsored by different groups such as the local Stillaguamish Band of Stanwood, the IOOF, and M. E. Cedarhome Sunday school.

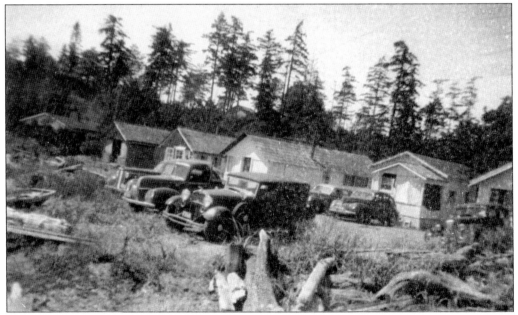

JUNIPER BEACH, PARKING IN DRIFTWOOD. Unlike the west side of the island, it was not a great place for boat rentals, but eventually the small lots on the beach were sold and family cabins lined the shore. Berniece Leaf remembers the beach had sand hard enough to golf and run on. Now it is silty, and it is hard to avoid sinking.

Woolen Bathing Suits at Juniper Beach. In 1926, young Joyce Rickman of Juniper Beach, at the age of three, is pictured here with friends, all in itchy woolen bathing suits. The water would warm up on the tide flats that stretched for miles into Port Susan. (Courtesy Joyce Rickman.)

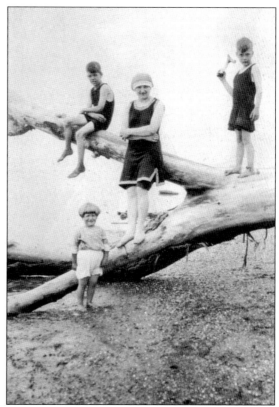

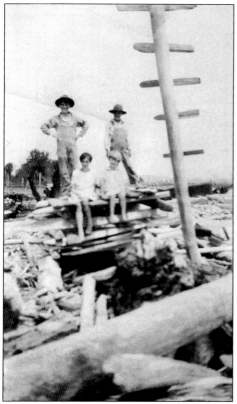

Driftwood Shelters, a Beach Tradition. No child can resist the temptation to build their own beach shelter from driftwood. According to Bernice Leaf of Juniper Beach, "We cleaned our driftwood houses and made little rooms. In the kitchen we put wood and shell utensils safely away along with peanut butter and crackers. We made furniture for living rooms and brought down old towels for beds. What fun!" (Courtesy Joyce Rickman.)

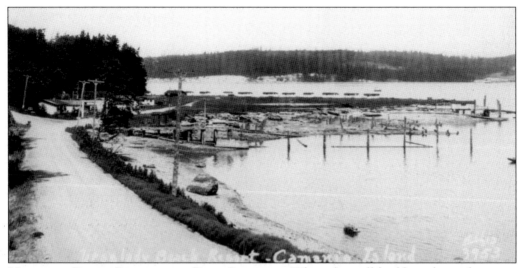

UTSALADY BEACH RESORT AND BOAT LANDING. When the mill buildings burned or were finally gone at Utsalady Point, vacation cabins were built to rent to fishermen and campers. The camp was known first as Pioneer Beach, then Utsaladdy Beach. The resort beach cabins are in the distance with Whidbey Island beyond in this photograph. The dirt road in the foreground followed the shoreline east to New Utsalady and was partially built on pilings out over the beach. The county later bypassed it with a road above.

UTSALADDY
BEACH CABINS
ADVERTISEMENT, 1940.
Throughout the history of Utsalady, the spelling of the word has been controversial. Early mill records and most old newspapers and histories show it spelled with one "D," while someone later adopted two "Ds," and both are used. It is now most often seen with one "D."

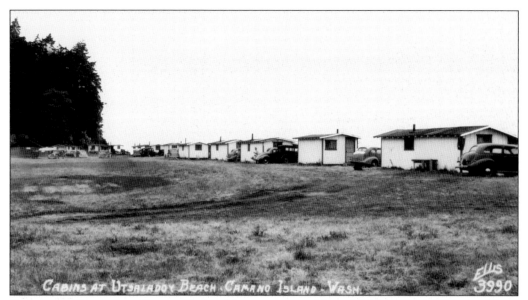

CABINS AT UTSALADDY BEACH. Early cabin owners were Victor Nicklason and Ed Fowler. There are also references to Bardwell's cottages there, perhaps an earlier name. Ted Rolfson operated a boathouse there.

THE FLOODED BEACH CABINS AT UTSALADY POINT, C. 1935–1939. With Strawberry Point on Whidbey Island in the distance, John Olson, proprietor of the Utsaladdy Beach Resort, stands in flood waters caused by high tide and a storm surge from the northwest. The photograph was donated by Harry L. Lund, who worked at the resort during the Great Depression and remembered working seven days a week, 10 hours a day for $5.

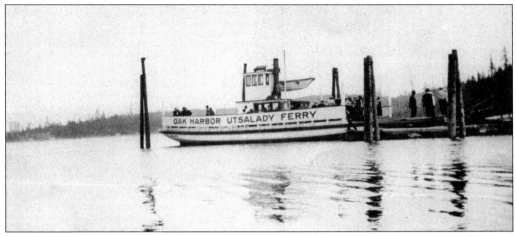

OAK HARBOR AND UTSALADY FERRY. In 1925, ferry service began between Whidbey and Utsalady and ran until 1936 when the Deception Pass Bridge was completed. The captain was Berte Olson, short but determined and able to handle a "man's" job even after she and her husband parted ways.

Oak Harbor-Utsalady Ferry

Summer Scheedule—Daily

EFFECTIVE May 1st, 1930

—Leaves Utsaladdy: 7:30 a. m., and every hour on the half hour until 7:30 p. m. except 11:30 a. m.

—Leaves Whidby Island: 8:00 a. m., and every hour until 8:00 p. m. except 12 noon.

PHONE STANWOOD 106-R-3

Ferry lands on Whidby Island— Near Oak Harbor

Subject to Change Without Notice

FERRY SCHEDULE. This schedule appeared in the *Twin City News* in July 1930.

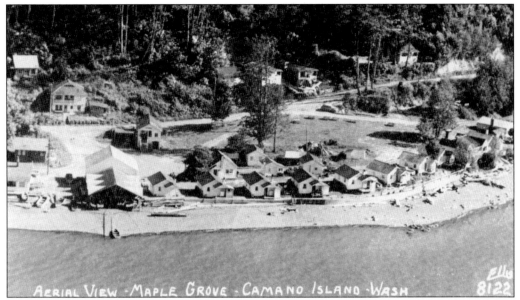

MAPLE GROVE RESORT AND BOAT LAUNCH. The Maple Grove Resort was established by Charlie Brown, who came to Camano Island as a logger and then operated the boat rental business at Camp Grande for a short time. He began clearing land and building a road for the Maple Grove Resort in 1930. It had 650 feet of waterfront with 12 cabins and 3 cottages.

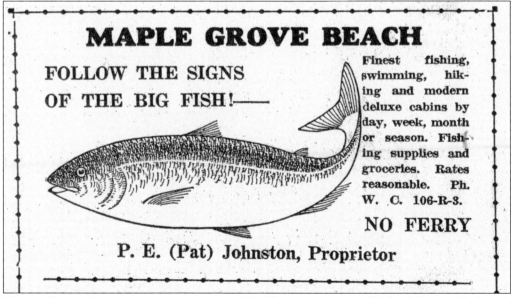

MAPLE GROVE BEACH ADVERTISEMENT, 1939. There is now a small Island County Park with a boat launch where the boathouse used to stand. It is one of the few places to launch a boat on Camano Island.

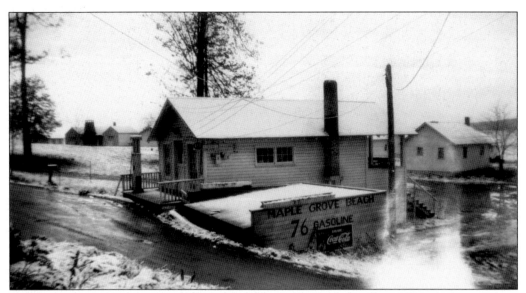

MAPLE GROVE RESORT STORE AND GAS PUMP. In 1944, Charlie Brown sold Maple Grove Resort to the Kraetz brothers, who sold it to Les and Theresa Hagstrom. Its last owners were Bob and Fran Neale, who purchased it around 1950. The boat ramp is still there, but the boathouse has been taken down.

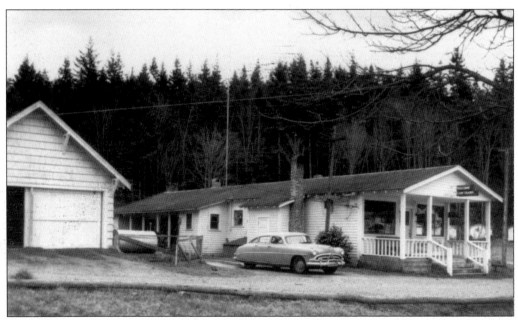

CAMP GRANDE STORE, C. 1956. One of the largest and earliest resorts was Camp Grande, which was started by Herb Davis in 1927. Named after a camp near the Rio Grande River in Texas, Davis started the camp after staying at Utsalady the previous summer and operated Camp Grande until 1940. The resort owner's house was behind the store. "Penny candy and pop were the big sellers." This photograph was taken when the resort was purchased by Sherman and Inga Bast in 1956.

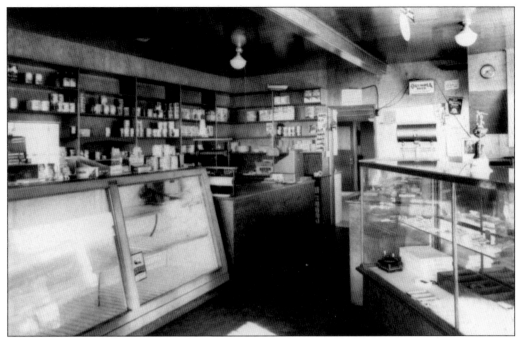

CAMP GRANDE STORE INTERIOR. The store had a refrigerator and deep freeze. Meat was brought in from Mount Vernon. Over the years, owners included Bert Medford, the Stephensons, Inga and Sherman Bast, and W. B. Ward and sons. In the early years, water was piped from a spring, and it was a precious commodity. Once when Davis was having trouble keeping the water pressure up, he discovered the problem to be guests who were cooling drinks in the sink with running water.

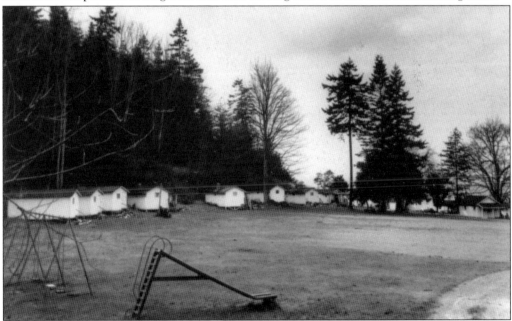

PLAYGROUND OF CAMP GRANDE. The playground, buildings, and small cabins of Camp Grande still exist but are owned privately by a real estate investment trust. According to one of the later resort operators, there was a recreation hall with a jukebox.

CAMP GRANDE ADVERTISEMENT FROM WASHINGTON MOTORIST, JUNE 1939. According to one of the resort owners, Inga Bast, one year Camp Grande hosted 15 different square-dance groups for a week at a time, as well as church groups, Camp Fire Girls, Boy Scouts, Eagles, and Moose lodges. The Madrona Fire District salmon barbecue served 750 people, and over the years the event grew so popular that it eventually moved to the South Camano Grange. The resort operated until about 1969.

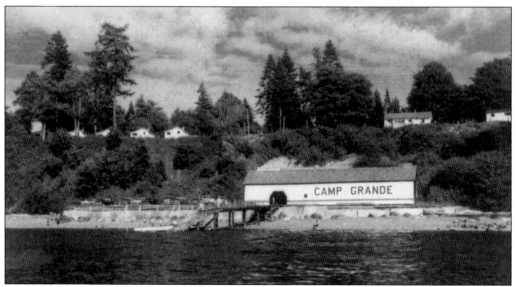

CAMP GRANDE BOATHOUSE. The boathouse still stands along the northwestern shoreline of Camano Island, a landmark on the Sound since the 1930s. During the early years, a 52-pound salmon was caught by a Mrs. Bennett. It took her one hour and 45 minutes to bring it in over the side of the small, rented kicker boat.

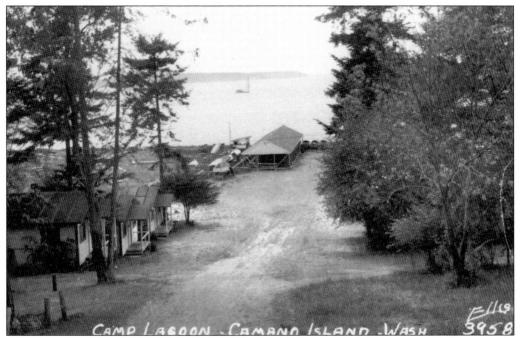

CAMP LAGOON'S BOATHOUSE. Camp Lagoon was established in 1932 by Art Pederson. Fifteen cabins, with a sewage system, were built, including septic tanks located centrally to service all cottages. In 1931, a Mr. Major had the lagoon filled in by a homemade gas donkey with a scoop dredge, and the boathouse was built in 1933. In 1945, it was taken over by Chester Brown. Unlike Camp Grande, this boathouse is long gone.

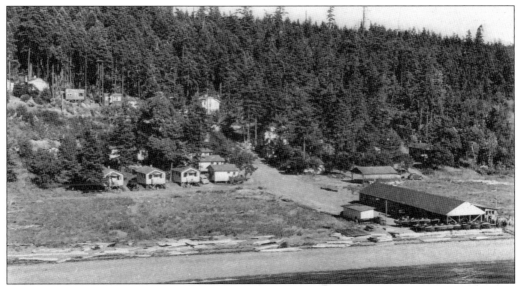

CAMP LAGOON'S COTTAGES AND BOATHOUSE. The resort included 315 feet of water frontage and eventually 15 cabins near the current Lagoon Way. A store was built, as well as two community kitchens that included double stoves for a camper's conveniences and tables to accommodate 30 people for each kitchen. A few of the cabins have been converted to residences. (Photograph by J. Boyd Ellis, No. 3979.)

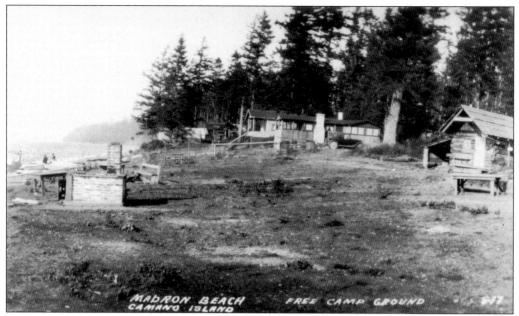

MADRONA BEACH, FREE CAMPGROUND. Farther south, down the same stretch of beach, was the Madrona Beach Resort. Note the outdoor brick barbecue that was used to prepare crab, clams, and fish. There is a creek that has since been diverted underground here, and it must have seemed to be a natural place to camp for winter and prepare seafood as the Native Americans did.

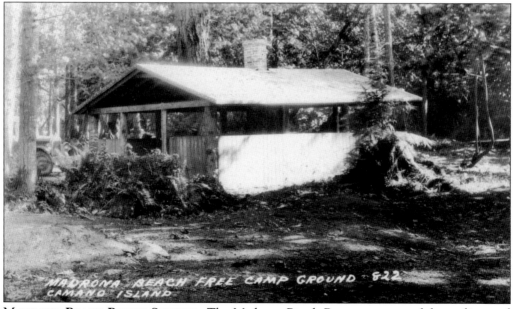

MADRONA BEACH PICNIC SHELTER. The Madrona Beach Resort was one of the earliest and largest; it was established by Henning Sandberg in about 1926. In 1955, Clinton Parker took over and also established a rural postal station in 1956 that was discontinued in 1969.

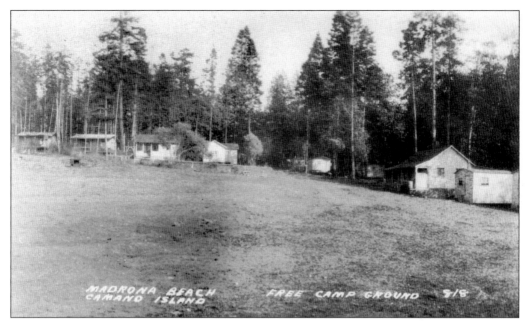

EARLY CABINS AT MADRONA BEACH. The area was platted by Tom Inions and Stephen Floe, realtors, who sold surrounding lots for cabins. An article in a March 1926 edition of the *Stanwood News* describes the "new colony of summer homes to be established about half way between Camano City and Rocky Point at a place which has always been known as Camp 2." This was the logging camp operated by the Esarys and Garrisons.

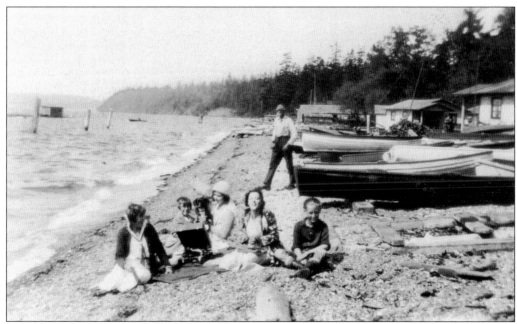

RECORD PLAYER ON THE BEACH AT MADRONA. These unidentified picnickers brought their record player to the beach for some added entertainment. The Madrona resort boathouse was located with a store near the current Stanwood Camano Yacht Club.

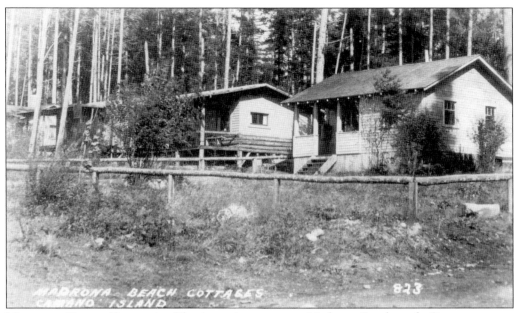

MADRONA BEACH COTTAGES. Classic rustic cottages at Madrona Beach made Camano a great getaway. Note the rustic pole fences.

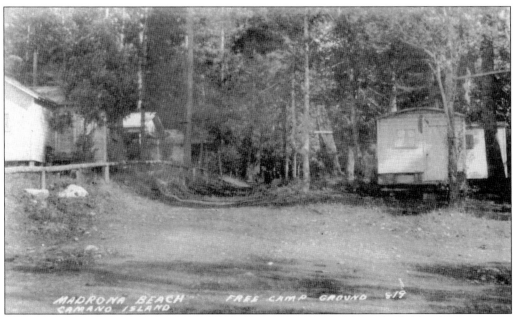

MADRONA BEACH, FREE CAMPGROUND. These cottages, or cabins, look like they were just brought in and laid on pilings.

GOOD SALTWATER FISHING. This is a business card for the manager of Madrona Beach Resort. As previously noted, Herb Davis also ran his own resort, Camp Grande. The management of the Madrona resort was later taken over by Edan Johnson. There was a popular recreation and dance hall at Madrona also, but it is unclear where it was located..

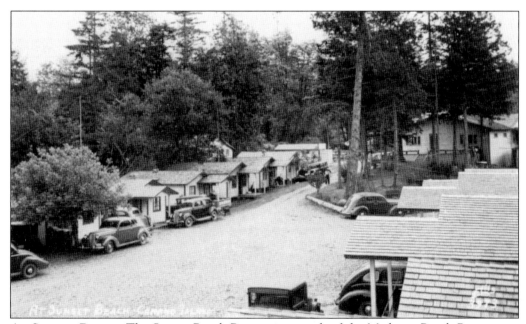

AT SUNSET BEACH. The Sunset Beach Resort, just south of the Madrona Beach Resort, was started about 1935 by Art and Mary Pease. It was built on filled-in lagoon. The Peases sold the resort in 1945 and started The Island Café. As of 2006, the café building storefront stood empty at the intersection of Madrona Beach Road and Sunset Drive..

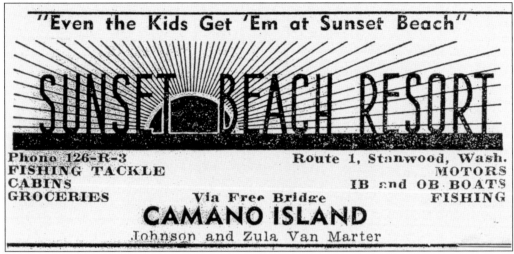

"Even the Kids Get 'Em at Sunset Beach"

SUNSET BEACH RESORT

Phone 126-R-3 Route 1, Stanwood, Wash.
FISHING TACKLE MOTORS
CABINS IB and OB BOATS
GROCERIES Via Free Bridge FISHING

CAMANO ISLAND

Johnson and Zula Van Marter

SUNSET BEACH RESORT. This advertisement appeared in the *Pacific Northwest Sportsman* in 1948. Sunset Beach was among the many resorts that participated in the sportsman's' derbies, started in the early 1940s, that offered attractive prizes, including a boat and motor. Somewhere south of Sunset Beach was the Clough Beach Resort and Rockaway Beach that was around about 1950, though no pictures have been found and exact dates are unknown.

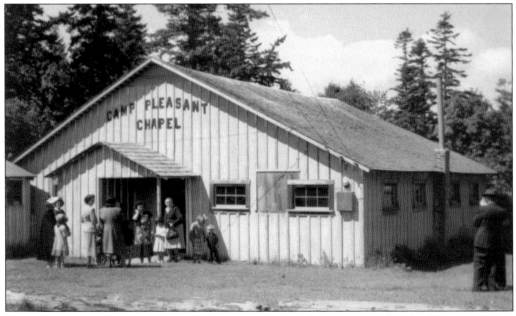

CAMP PLEASANT. Past the Sunset Drive resorts, the road intersects with West Camano Drive. At the intersection of Camano Hill Road were two resorts—Onamac Park and Camp Pleasant. Camp Pleasant was started around 1929 with a few cabins. There was a round building for picnics and a residence with a recreation hall attached. It was later used for church services.

CAMANO BEACH RESORT AT CAMANO CITY. The Camano Beach Resort was started around 1926 by Michael and Bernice Keating. The cabins were built on top of the hill, but moved down to the beach in 1931. The mills were located where the cabins are lined up against the hillside. Ted Wicks advertised 14 cabins in the 1950s and early 1960s. Twenty-six boats with motors were available, along with tackle for fishing. The cabins were available in the hunting season as well.

Camano Beach

A Delightful Spot on the Sound

Where you can enjoy a day, a week

or a month

BOATING — BATHING
WONDERFUL FISHING
COMFORTABLE CABINS
CONVENIENT CAMP GROUND

Michael Keating
Stanwood, Route 1

Telephone
Stanwood 102-R-21

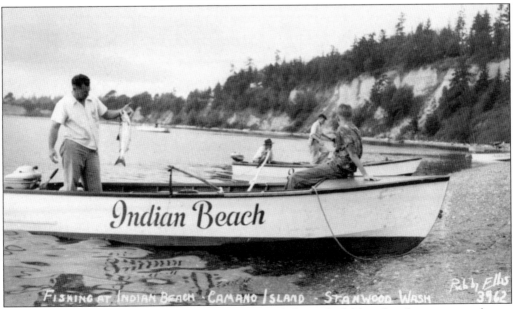

FISHING AT INDIAN BEACH. Camano Island provided wonderful beaches for picnics and were often at the same places as early Native American villages—usually a level place to build a shelter with a water source. The relatively large barrier beach or small cape that became the Indian Beach Resort around 1924 was a site where Native Americans stayed to gather mussels and clams during the summer. Its name was *hwigsap'*.

113

Camp Comfort

Eleven New Furnished Cabins

Two Community Kitchens—one directly on the beach—other at cabins

Boats for Hire

Wonderful Swimming Beach

TENT CAMPERS—PLENTY OF ROOM

CAMP COMFORT ADVERTISEMENT, SUMMER 1930. On the same beach as Indian Beach Resort was Camp Comfort, which had 11 cabins, two community kitchens, boats, and a wonderful swimming beach. It was owned by John Blomquist and managed by Ben and Margaret Sollie in the 1930s. Around 1947, the Blomquists began selling lots of the camp as private cabins.

ED ALLISON ROD JEFFERS

OPEN ALL YEAR

MANACO RESORT

(Formerly Reid's)

BOATS and MOTORS
MODERN CABINS
GROCERIES
TACKLE

Rt. 1, Box 214, STANWOOD, WN.
Phone West Coast 104R21

MANACO RESORT ADVERTISEMENT, *PACIFIC NORTHWEST SPORTSMAN*, APRIL 1948. Started as Campbell's then as Reid's resort, the name was changed to Manaco Resort by Mel and Mary Bloom, who purchased it in 1946. It had 10 cabins, 12 to 15 boats, and a little store. It has long since been divided into lots and developed as Manaco Beach. Manaco is an anagram for Camano.

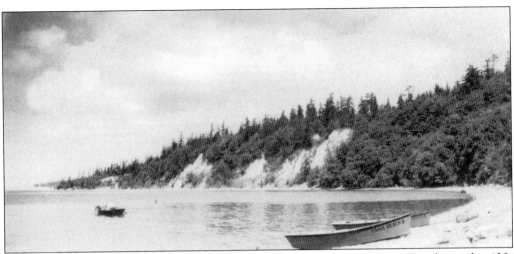

CAMA BEACH RESORT SHORELINE. Just a quarter mile south of Manaco Beach are the 400-plus acres of forest and almost a mile of shoreline that were once the Cama Beach Resort. This photograph looks north along the shoreline from the resort toward Manaco in the distance.

CAMA BEACH VIA STANWOOD. The Cama Beach Resort opened in 1934 and was developed and managed by Leroy Stradley, former publisher of the Seattle shipping paper, the *Daily Index*. He vacationed with his family near Erickson's Island near Milltown, and in the early years of the Great Depression, he began building the resort. Stradley died suddenly in 1938 and was not able to follow through with further development. However, his wife, Lucy, and his daughter and son-in-law, Muriel and Lee Risk, continued to operate it. It stayed open long after most of the other resorts on the island closed.

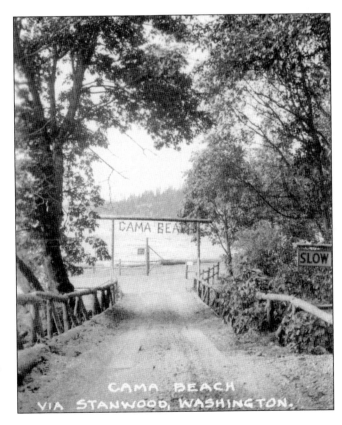

115

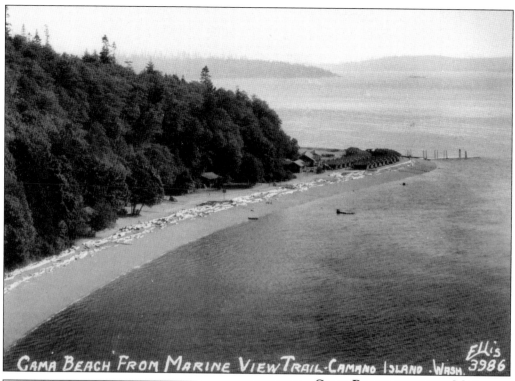

CAMA BEACH FROM MARINE VIEW TRAIL - CAMANO ISLAND, WASH. Ellis 3986

CAMA BEACH FROM THE MARINE VIEW TRAIL. This bird's-eye view of the resort shows the extent of cabins available and an early floating dock. A larger boathouse was built in 1950. The resort was built on the barrier beach and lagoon used by Native Americans as a summer camp called *Ya-lk'ed*. In 1906, it was a logging camp.

CAMA BEACH ADVERTISEMENT, WASHINGTON MOTORIST, JUNE 1939. The resort was advertised in Seattle and beyond and had guests from as far away as California and Texas.

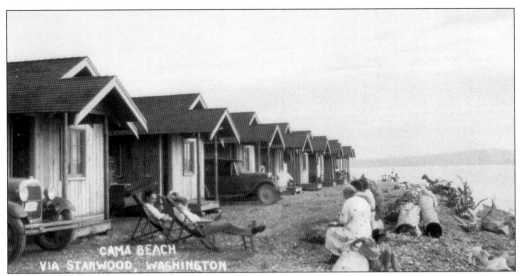

CAMA BEACH CABINS. One of the most impressive characteristics of the Cama Beach Resort was its architectural uniformity. The cabins were laid out in precise rows right on the edge of the beach. The cedar cabins still stand on their original cedar pilings at this writing, though are soon to be replaced as the resort cabins are rehabilitated. Each had one little bedroom and a kitchen table and sink, wood stove, cupboards, and pie cabinet.

CAMA BEACH BUNGALOWS. On the northern stretch of the shoreline were nine bungalows. These bungalows had more elaborate accommodations than the cabins with two bedrooms, a fireplace, and large front porches. Water could be heated in a tank connected to the stove. Two of the original cabins survive, adapted as state park buildings. The rest were damaged beyond repair by landslides.

117

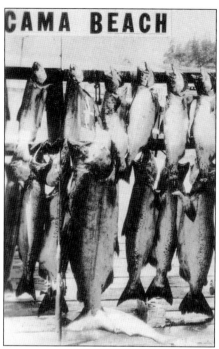

FISHING, THE MAIN ATTRACTION. The fishing declined over the years. According to Lee Risk, the manager of the Cama Beach Resort, they tried providing a variety of activities to entertain guests—building a tennis court and ping pong rooms, offering swimming lessons, hosting square dances and occasionally music, and showing films. The former resort facilities are now on the National Register of Historic Places; the weathered cedar buildings survived the elements making the property well worth preserving as part of the Washington State Parks.

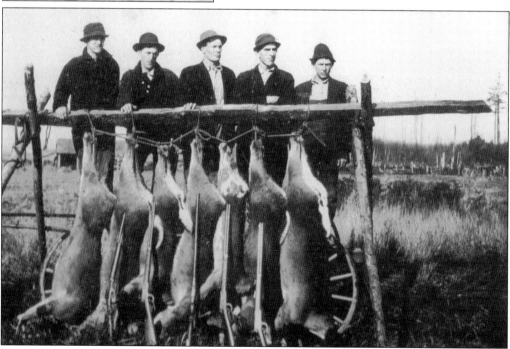

HUNTING ON CAMANO ISLAND. For tourists, Camano was a popular place for hunting, and sometimes resort cabins were rented to hunters. Oscar Bodin (left) and Erickson family members, loggers who worked in many camps on Camano, hired a photographer to capture this hunting trip on camera. The deer population grew after the tall trees were cut and there was plenty of browsable brush for them. Venison was always a staple for residents, especially during the Great Depression. (Photograph by John T. Wagness.)

Eight

Transition and Self-Reliance

Camano Island's economy was never the active manufacturing center the Utsalady Mill had been for its day. Small-scale logging companies continued through the 1920s, but the transition to a replacement economy never materialized. Because it was off the beaten path, land values were not high. Poultry farms were enthusiastically tried, but it was difficult to get eggs to the market. There were strawberry fields at Barnum Point and Cavalero Beach, even goat and fox farms. But most folks were pretty poor. Often it was a long wait for the check from the logging shipment to come in. They made use of the large rabbit and deer populations for food. The local Stanwood newspaper included Camano gossip columns written by community contributors, but there was very little business news in Camano.

Along with other rural areas of Puget Sound, as soon as it was logged, land became the most valuable resource. To make it accessible all over the State of Washington, road building was in demand. No less so on Camano. Local businessmen who wanted to have jobs on the island saw the need to join the good roads movement and build roads, even if they had to do it themselves. In February 1922, C. M. Brown donated $156 to help defray costs of building roads. He organized businessmen and workers, whoo "provided $500 in donated labor, spread 200 yards of gravel (without bulldozers), dug a five mile ditch and dragged ten inches of road." In 1930, as Island County commissioner, M. T. Brown (C. M.'s brother) was an active advocate in promotion of building roads all over the region. It was then that the switchback curve up Land's Hill on the state highway was straightened.

INTRODUCTION

South Camano Grange is located on Camano Island, a small island between Whidbey Island, several times as large, and the mainland. Across a primitive bridge are its marketing centers, Stanwood and East Stanwood, in Snohomish County.

It has approximately 925 registered voters, mostly retired people, farmers and fishermen.

Camano and Whidbey Islands form Island County. To reach Coupeville, the county seat on Whidbey, Camano residents must drive 100 to 140 miles, round trip, through Snohomish and Skagit Counties.

County activities and government have always centered on Whidbey, and county offices have been filled by members of a certain few families living there. One county commissioner is customarily elected from Camano, our only voice in county affairs.

Because of these facts, and of infrequent contacts, county officials have had little knowledge of our conditions or interest in them, and because no organized effort has been made to present our problems or secure action correcting them, bad situations have become and remained chronic.

These were so numerous that South Camano Grange established a Planning Committee to study the needs of Camano Island and take every possible step to alleviate them. We entered the National Community Service Contest partly because it seemed a good focusing point for our problems and our efforts, a means of solving our problems and of unifying our community for better understanding and a better life for all of us.

SOUTH CAMANO GRANGE EXPLAINS GOALS: NATIONAL GRANGE COMMUNITY SERVICE CONTEST. In 1949, there were about 1,000 people living on Camano Island. As in other parts of the country, a grange was established (in 1930). The Grange is a rural agricultural fraternal group that includes women and children and advocates progressive rural social and economic programs. The South Camano Grange was also famous for its annual clam dinners and dances. On Camano, the chapter introduction above conveys how the residents were feeling about conditions on Camano and organized to change the situation. The projects that the Grange worked toward included revaluation of property, securing road improvement funds, selection of a suitable garbage dump, building a community playground, cemetery cleanup, tuberculosis testing services, and repairing and painting of the Lutheran church, Mabana schoolhouse, and Utsalady Ladies Aid building.

BY PROCLAMATION

500 Public Spirited WORKERS WANTED

Wednesday, July 27

500 Free-Will Workers wanted from Stanwood, East Stanwood and Camano Island to join in a big community gathering in clearing the Camano Island Public Park area of underbrush and small trees, make roads, and paths and constuct service buildings. Every man and woman who can possibly come, bring working tools, such as axes, saws, brush hooks, spades, rakes and picks. Some refreshments will be available on the grounds, but bring a picnic dinner if you wish.

Located at Point Lowell o Elger Bay on West Shore.
92 acres Shoreline and Woodland. Follow the Signs.

Division Captains

Chain Saws — A. V. Bucklin and Tess Cohee	Pitchfork Squads — A. J. Naylor and John Nelson
Carpenters — Mike Wagner and Robert Parcher	Axe Squads — Chick Johnson, Dennis Harnden and Melvin Olsen
Farm Tractors — Martin Mikkelsen	Doctor and Hospital — Dr. R. C. Fisher
Bulldozers — Art Moa	Trained Nurse — Mrs. Margaret Treneer
Trucks and Pickups — Leonard Tiege and D. P. Garrison	Grange Photographer and Co-chairman — Ray Katzenberger
Pick and Shovel Squads — J. E. Goff, O. W. Hedbloom, Harold A. Moe and Harry Olsen.	Timekeepers — E. K. LeBlond, Mrs. Marie Ruggles and Bill Lawrence.
Brush Hook Squads — LeRoy Pollock, Gus Rozell, John Olsen and W. H. Strever	Pop and Ice Cream Concession — Betty Harnden
	Traffic Director — Benny Sands and Assistants

Join the caravan of cars leaving the Twin Cities at 8:00 A. M

The Advertising for This Great Project Underwritten by

Norman F. Bates	Modern Shoe Service	Kris's Market	The Mercantile Co.
Arthur Sargent	Stanwood Recreation and Employment	Stanwood Steam Laundry	East Side Tavern, Paulson & Odegaar
Hazel C. Hall Agency	Camano Service Station	Lien's Sport & Variety	Wallace Motors
J. H. McElroy, Realtor	Allan's Cash Grocery	Twin City Cab	C. J. Gunderson Funeral Home
Skagit Refrigeration Service	Stanwood Plumbing & Sheet Metal	Josephine Sunset Home	Olav Furuheim
The First National Bank	E. A. Bryant Hardware	Rev. and Mrs. O. L. Haavik	Glenn, the Barber
Norton's Food Center	Twin City Dairy	Chic Beauty Shoppe	Hanson's Cafe
Koester Electric	Moe's Tavern	Eilertsen Lumber Co.	Hanson's Variety Store
Maynard Larson Service	Stanwood Millwork	Milky Lane Drive Inn	Fred Tucker
Stanwood Paint & Body Works	Hall's Service & Transfer	Floe's Transfer	Rouse & Muncie
Taxi Inn And Cafe	Palace Market	O. K. Bell, Western Store	Depot Service Station and Garage
Dr. Kowalski	Hansen's Radio Service	J. M. Knutsen, Realtor	Western Store
Twin City News	Stanwood Hotel and Tavern	Twin City Grain Co.	The National Bank of East Stanwood
Mark Kimball	Central Cafe	Jim Hansen's Shurfine Grocery	Oscar Wenberg
Stanwood Auto Co.	Stanley's Barber Shop	Landry's Blacksmith Shop	Bloxham Machine Shop
Colonial Theatre	Hartneys	Pastime Confectionery	S. N. Sorensen, Photographer
Clyde's Tavern	Nelson's Cycle Shop	Home Meat Market	The Mercantile Dry Goods
Stanwood Drug Store	Stanwood Service Station	Goplin Drug	Amundson's Men's Shop
Harold Knudson, Jeweler	Stanwood Hardware & Furniture Co.	Twin City Bakery	Oberg-Backstrom Motors
Stanwood Junk Co.	Dr. E. G. Wheeler	Fred Misner—Chevron Service	
Twin City Foods Inc.	Gilbertson Hardware	C. J. Gunderson	**Free Bus Transportation Fror**
J. E. Hamilton & Sons, Inc.	East Stanwood Furniture Store	Templeton's Mobil Service and Lunch	**East Stanwood at 8:00 A. M.**

VOLUNTEERS FOR STATE PARK DAY. The most impressive accomplishment of the South Camano Grange for the contest was the organization of 500 volunteers to build a new state park in one day in July 1949. The Grange had petitioned the Washington State Parks Commission, and the state set aside 92 acres of school land at Point Lowell, identified by Ben Sollie, for a park. The State Parks commissioner asked that volunteers contribute time to develop the Camano Island State Park project.

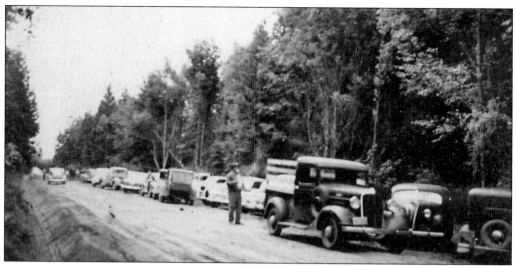

AUTOMOBILES LINED UP TO PARK AND REGISTER TO VOLUNTEER. Mayors of both Stanwood and East Stanwood cooperated by proclaiming a state park day, and merchants promised to close for a day and bring their employees to work.

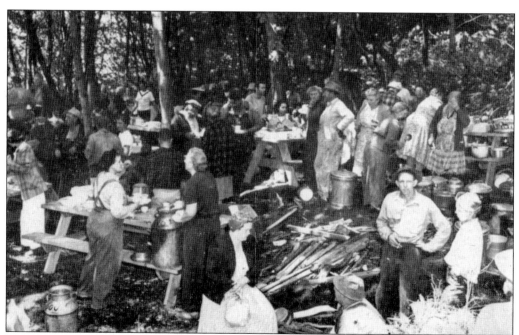

FEEDING THE VOLUNTEERS. In their description of the project, the Grange said, "Our entire shoreline was owned by individuals, resorts, or real estate or lumber companies, except ninety feet in three different points owned by the County, these not generally known. The general public had no access to the beach"—yet they lived on an island! Here the ladies are serving traditional clam chowder, coffee, sandwiches, cookies, pop, and ice cream to the volunteers.

"CLEANING OUT THE SPRING." One of the projects included providing water for the park. Here workers are cleaning and tiling the spring making it ready for the pump and piping.

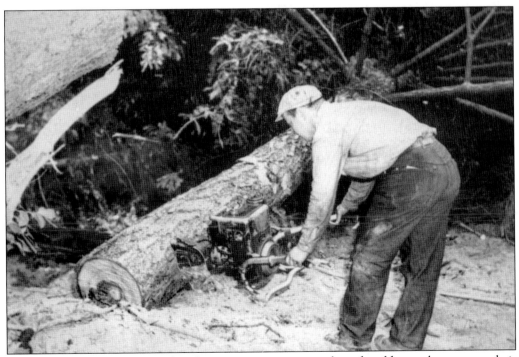

EARLY MODEL CHAIN SAW. This chain saw seems pretty awkward and heavy, but apparently it could cut the tree. Three bulldozers, nine farm tractors with equipment, 34 pickups and trucks, one large trailer truck, three wreckers, and a team of horses worked all day.

CAMANO ISLAND STATE PARK SIGN. At the end of the day, the volunteers had picnic tables erected, land and paths cleared, a road and parking area leveled, and a place for everyone to get to the beach. All labor—3,561 man-hours, 376 machine hours, and all expenses—were donated. Estimated value of the work was $6,000.

SOUTH CAMANO GRANGE BUILDING, C. 2003. The South Camano Grange won third prize. It must have been heartbreaking, because it is hard to imagine a more organized and worthy cause. For the whole project, over 12,552 hours were donated, with help from 500 non-Grangers, 200 Grangers, and $75 cash. All machinery and equipment—working 1,551 hours—and nearly all operating expenses were donated. The Grange building was built in 1932 and still serves as a community building for meetings, music, dinners, camping groups, dancing, and gatherings of all kinds.

TWO BRIDGES, 1950. In 1940, residents began to request that a new bridge be built from Stanwood over the Stillaguamish River to replace the 1909 swing bridge. In 1945, a bill passed that added the road from "U.S. 99 to McEacheran's Corner" (now Terry's Corner) on Camano Island to the state highway system. It was then called SSH 1 Y (Secondary State Highway 1 Y). In 1964, it became State Route 532. This enabled the legislature to appropriate funds to build the bridge in 1947. On July 23, 1950, the Gen. Mark Clark Bridge was dedicated. It was named after the World War II army officer who served in Europe under Gen. Dwight Eisenhower. He and his family vacationed and fished on the island and considered retiring here. Though his wife spent time here, other opportunities came up for him, and he never settled down here.

Census of Camano Island, Island County, Washington

Year	Population
1780 –	1,500-2,500 Salish people on Whidbey & Camano
1850 –	1,059[white] inhabitants north of the Columbia River
1855 –	Island County, 195 (incl. Snohomish, Skagit Counties at the time)
1860 –	58 millmen at Utsalady
1870 –	157 people at Utsalady with about 54 houses
1880 –	187 "Utsaladdy"
1889 -	390 Washington Territorial Census
1890 –	[Island County - 1,787]
1892 -	187 Washington Territorial Census
1900 –	460
1910 –	678 [Utsalady 511; Camano 167]
1920 –	910 [Utsalady 267; Camano 163; Livingston Bay 330; Mabana 150]
1930 –	679 [Utsalady 196; Camano 117; Livingston Bay 274; Mabana 92]
1940 –	876 [Utsalady 183; Camano 265; Livingston Bay 281; Mabana 147]
1950 –	1,160
1960 –	1,393
1970 –	2,600
1980 –	5,080
1990 –	7,329
2000 –	13,347

Sources: U. S. Censuses of Population & Territorial censuses

CAMANO ISLAND CENSUS FIGURES. During its first century, Camano Island's residents were a mix of loggers, small family-run construction companies, and small-scale farm or resort owners. As the properties were sold, they began to lose access to the open space and beaches for their traditional picnics and boating outings. They were also far away from any government, social, or economic services. This small community, however, took the initiative to develop a state park and build a new bridge to connect to the outside world.

Utsalady Point Park, Camano Island. In 1979, members of the Stanwood Area Historical Society in Stanwood (Snohomish County), Washington dedicated the wooden relief carving (45 inches by 95 inches) of the Utsalady Mill on the hillside in the county park above Utsalady Point on Camano Island (Island County). The carvings were done by Gene Remington and Carl Strever. With this effort, SAHS acknowledged its important historical and geographical tie to Island County and Camano Island.

BIBLIOGRAPHY

Andrews, Ralph. *This Was Logging!* Seattle, WA: Superior Publishing Company, 1954.

Cherry, Lorna. *South Whidbey and Its People, Vols. 1–3.* Langley, WA: South Whidbey Historical Society, 1983–1986

Conroy, Dennis. "Pioneers of Utsalady." *Columbia Magazine.* Spring 2000: 7–12.

Conroy, Dennis. "The Utsalady Sawmill." *Short Lines Tall Timbers.* Spring 2001: 9–22.

Essex, Alice. *The Stanwood Story, Vols. 1–3.* Stanwood, WA: Stanwood/Camano News Printing, 1971–1998.

Hawes, E. M., and Lou Clark. "Island County—A World Beater." Langley, WA: South Whidbey Historical Society/Everett, WA: F. B. Hawes Company, 1911.

Kellogg, George Albert. *A History of Whidbey's Island [Whidbey Island].* Coupeville, WA: Island County Historical Society, 1934.

Kimball, Art, and John Dean *Camano Island: Life and Times in Island Paradise.* Stanwood, WA: Stanwood/Camano News Printing, 1994.

Osmundson, John. "Camano Island—Succession of Occupation from Pre-Historic to Present Time." *The Washington Archaeologist.* April 1961: 2–18.

Suttles, Wayne, and Barbara Lane. "Southern Coast Salish." Handbook of North American Indians. Washington, D.C.: Smithsonian Institution, 1978–1990: 485–502.

Vancouver, George. (W. Kaye Lamb, ed.) *A Voyage of Discovery to the North Pacific Ocean and Round the World, 1791–1795, Vol. II.* London, England: The Hakluyt Society, 1984.

White, Richard. *Land Use, Environment, and Social Change: The Shaping of Island County, Washington.* Reprint Edition. Seattle, WA: University of Washington Press, 1992.

Much of the information was found in issues of the *Stanwood Tidings, Stanwood News,* and *Twin City News* (early names of the current *Stanwood Camano News*). See also our bibliography at http://www.sahs-fncc.org/SAHSbib.html, which includes links to Native American resources.

ACROSS AMERICA, PEOPLE ARE DISCOVERING SOMETHING WONDERFUL. THEIR HERITAGE.

Arcadia Publishing is the leading local history publisher in the United States. With more than 3,000 titles in print and hundreds of new titles released every year, Arcadia has extensive specialized experience chronicling the history of communities and celebrating America's hidden stories, bringing to life the people, places, and events from the past. To discover the history of other communities across the nation, please visit:

www.arcadiapublishing.com

Customized search tools allow you to find regional history books about the town where you grew up, the cities where your friends and family live, the town where your parents met, or even that retirement spot you've been dreaming about.